TWENTY

Story & Art by Von Gotha

PRIAPRISM PRESS

More books by Von Gotha

TROUBLES OF JANICE VOL 1, 2, 3

THE DREAM OF CECILIA

A VERY SPECIAL PRISON

TWENTY

ISBN 0-86719-470-7

Published in the United States by
Last Gasp of San Francisco P.O. Box 410067
San Francisco Ca 94141-0067

The story was originally published in France in the magazine BD X
by International Presse Magazine
All models are over 23 years of age.
Dealers are instructed not to sell this book to minors.

Lettered by Zoltan Mitic
Printed in Spain

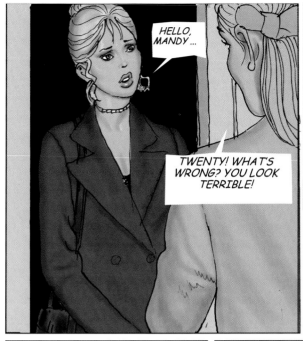

HELLO, MANDY...

TWENTY! WHAT'S WRONG? YOU LOOK TERRIBLE!

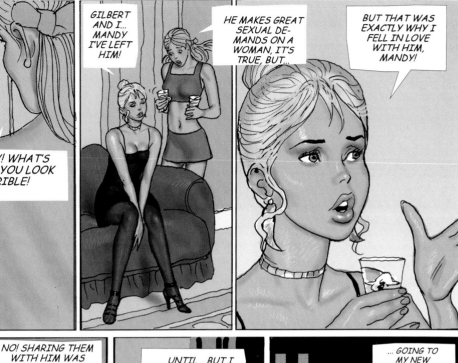

GILBERT AND I... MANDY I'VE LEFT HIM!

HE MAKES GREAT SEXUAL DE-MANDS ON A WOMAN, IT'S TRUE, BUT...

BUT THAT WAS EXACTLY WHY I FELL IN LOVE WITH HIM, MANDY!

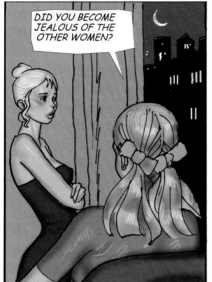

DID YOU BECOME JEALOUS OF THE OTHER WOMEN?

NO! SHARING THEM WITH HIM WAS TERRIFIC! OUR LIFE WAS EVERYTHING I HAD EVER DREAMED OF...

... UNTIL... BUT I MUST START AT THE BEGINNING... IN MY GUARDIAN'S CAR..

... GOING TO MY NEW SCHOOL... WHERE I WILL MEET YOU.. AND GILBERT... AND WHERE I'LL GROW UP! IT ALL STARTED...

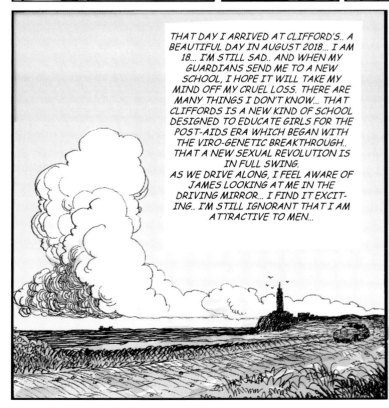

THAT DAY I ARRIVED AT CLIFFORD'S.. A BEAUTIFUL DAY IN AUGUST 2018... I AM 18... I'M STILL SAD.. AND WHEN MY GUARDIANS SEND ME TO A NEW SCHOOL, I HOPE IT WILL TAKE MY MIND OFF MY CRUEL LOSS. THERE ARE MANY THINGS I DON'T KNOW... THAT CLIFFORDS IS A NEW KIND OF SCHOOL DESIGNED TO EDUCATE GIRLS FOR THE POST-AIDS ERA WHICH BEGAN WITH THE VIRO-GENETIC BREAKTHROUGH.. THAT A NEW SEXUAL REVOLUTION IS IN FULL SWING.
AS WE DRIVE ALONG, I FEEL AWARE OF JAMES LOOKING AT ME IN THE DRIVING MIRROR... I FIND IT EXCIT-ING.. I'M STILL IGNORANT THAT I AM ATTRACTIVE TO MEN...

A SUBJECT AVOIDED AT THE CONVENT...YET I CAN ALMOST FEEL HIS EYES LINGER ON MY THIGHS.. GLIMPSES OF WHICH I DELIBER-ATELY BUT CAREFULLY PERMIT HIM...
AS WE PURSUE OUR JOURNEY, HIS EYES GROW THOUGHTFUL.... AND MY OWN THOUGHTS, MEMORIES OF HALF REMEMBERED DREAMS, COME BACK TO INCREASE THIS UNEASY EXCITEMENT.. I BEGIN TO SPECULATE TO MYSELF WHAT HIS THOUGHTS ABOUT ME MIGHT BE...

POOR KID...

1

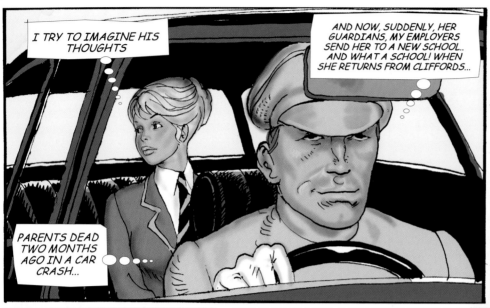

I TRY TO IMAGINE HIS THOUGHTS

AND NOW, SUDDENLY, HER GUARDIANS, MY EMPLOYERS SEND HER TO A NEW SCHOOL.. AND WHAT A SCHOOL! WHEN SHE RETURNS FROM CLIFFORDS...

PARENTS DEAD TWO MONTHS AGO IN A CAR CRASH...

SHE CERTAINLY WON'T BE THE 18-YEAR-OLD INNOCENT...

THAT SHE IS TODAY...

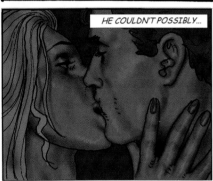

HE COULDN'T POSSIBLY...

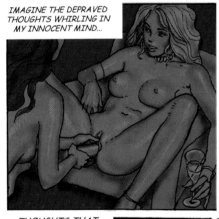

IMAGINE THE DEPRAVED THOUGHTS WHIRLING IN MY INNOCENT MIND...

.. THOUGHTS OF A GIRL ALONE IN THE COMPANY OF A MAN OTHER THAN MY FATHER FOR THE FIRST TIME SINCE I REACHED PUBERTY...

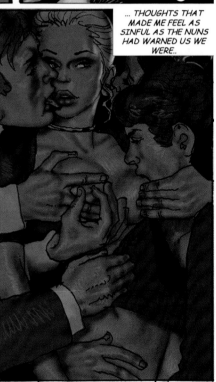

... THOUGHTS THAT MADE ME FEEL AS SINFUL AS THE NUNS HAD WARNED US WE WERE..

THOUGHTS THAT STRAYED INTO REGIONS...

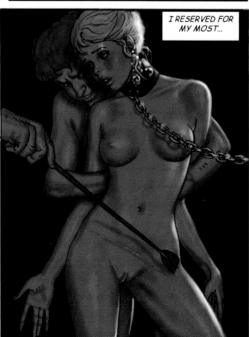

I RESERVED FOR MY MOST...

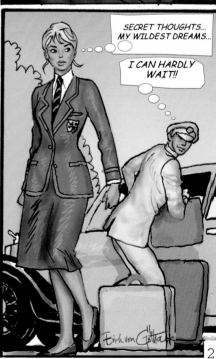

SECRET THOUGHTS... MY WILDEST DREAMS...

I CAN HARDLY WAIT!!

2

YET, WHEN JAMES HAD FETCHED MY BAGS AND I HAD MET MS. PALMER(UNEXPECTEDLY WEARING A SHORT SKIRT AND PLUNGING NECKLINE) THE THOUGHT THAT I WAS SOON TO BE PLUNGD INTO AN ORGY OF UNBRIDLED DEBAUCHERY NEVER ENTERED MY HEAD. BUT HER WORDS DISTURBED ME AS SHE SPOKE OF SEX... SEX, SHE SAID WAS THE GREATEST PLEASURE OF ALL... THE NUNS HAD TOLD US THAT THE GREATEST PLEASURE WAS THE LOVE OF GOD! NOW I HEARD THAT AT CLIFFORDS I WOULD LEARN TO GIVE AND RECEIVESEXUAL PLEASURE... I WAS THUNDERSTRUCK!

CLIFFORDS IS A FINISHING SCHOOL, TWENTY. YOUR GUARDIANS ARE CARRYING OUT YOUR PARENTS' WISH. THAT YOU SHOULD BE TRAINED FOR HE SEXUAL REVOLUTION THROUGH A SOUND SEXUAL EDUCATION HERE AT CLIFFORDS!

BUT I DID SEX EDUCATION, MS. PALMER!

BUT NOT, I EXPECT, PRACTICAL?

PRACTICAL??

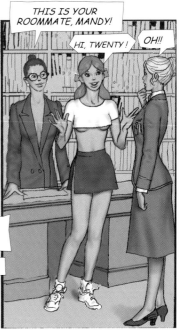

THEN YOU WALKED IN, MANDY! I WAS ASTOUNDED.. I HAD NEVER SEEN ANYONE WEARING SO LITTLE!

THIS IS YOUR ROOMMATE, MANDY!

HI, TWENTY !

OH!!

SHE WILL TAKE YOU TO CHANGE TO YOUR SCHOOL UNIFORM... DO YOU LIKE IT?

THAT'S THE SCHOOL UNIFORM ?!?

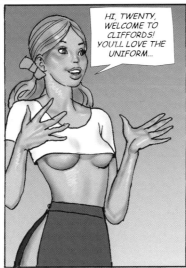

HI, TWENTY, WELCOME TO CLIFFORDS! YOU'LL LOVE THE UNIFORM...

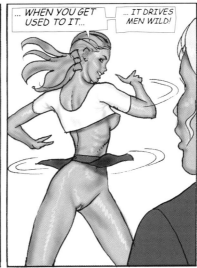

... WHEN YOU GET USED TO IT...

... IT DRIVES MEN WILD!

HA, HA! YES, IT DOES! TWENTY, ONE DAY, YOU'LL REMEMBER YOUR OLD UNIFORM WITH HORROR!

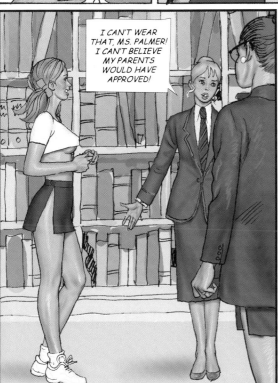

I CAN'T WEAR THAT, MS. PALMER! I CAN'T BELIEVE MY PARENTS WOULD HAVE APPROVED!

IT WAS THEY WHO ARRANGED THIS BEFORE THEIR TRAGIC ACCIDENT, TWENTY! THE VIRO-GENETIC REVOLUTION CHANGED EVE5RYTHING FOR THEM.. THEY REALISED IT MEANT SEXUAL FREEDOM.. ESPECIALLY FOR THEIR BELOVED DAUGHTER! IT IS YOUR DUTY TO THEIR MEMORY.. NOW OFF YOU GO!

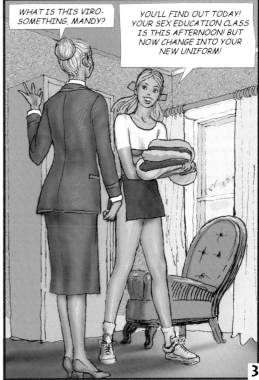

WHAT IS THIS VIRO-SOMETHING, MANDY?

YOU'LL FIND OUT TODAY! YOUR SEX EDUCATION CLASS IS THIS AFTERNOON! BUT NOW CHANGE INTO YOUR NEW UNIFORM!

3

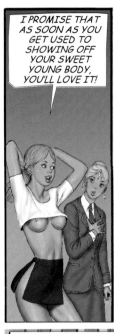

I PROMISE THAT AS SOON AS YOU GET USED TO SHOWING OFF YOUR SWEET YOUNG BODY, YOU'LL LOVE IT!

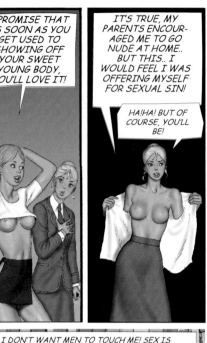

IT'S TRUE, MY PARENTS ENCOURAGED ME TO GO NUDE AT HOME.. BUT THIS.. I WOULD FEEL I WAS OFFERING MYSELF FOR SEXUAL SIN!

HA!HA! BUT OF COURSE, YOU'LL BE!

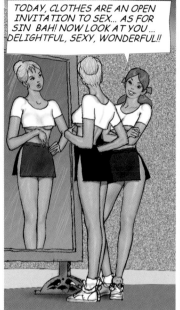

TODAY, CLOTHES ARE AN OPEN INVITATION TO SEX... AS FOR SIN BAH! NOW LOOK AT YOU... DELIGHTFUL, SEXY, WONDERFUL!!

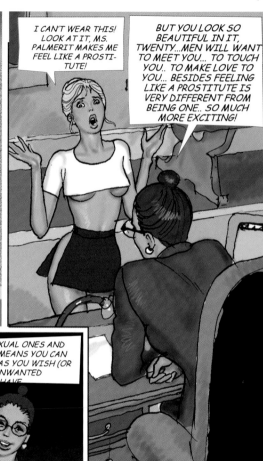

I CAN'T WEAR THIS! LOOK AT IT, MS. PALMERIT MAKES ME FEEL LIKE A PROSTITUTE!

BUT YOU LOOK SO BEAUTIFUL IN IT, TWENTY...MEN WILL WANT TO MEET YOU... TO TOUCH YOU.. TO MAKE LOVE TO YOU... BESIDES FEELING LIKE A PROSTITUTE IS VERY DIFFERENT FROM BEING ONE.. SO MUCH MORE EXCITING!

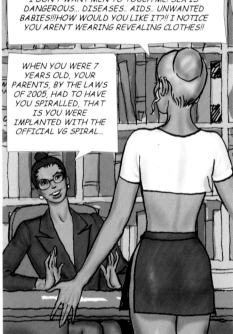

I DON'T WANT MEN TO TOUCH ME! SEX IS DANGEROUS... DISEASES.. AIDS.. UNWANTED BABIES!!!!HOW WOULD YOU LIKE IT?!! I NOTICE YOU AREN'T WEARING REVEALING CLOTHES!!

WHEN YOU WERE 7 YEARS OLD, YOUR PARENTS, BY THE LAWS OF 2005, HAD TO HAVE YOU SPIRALLED, THAT IS YOU WERE IMPLANTED WITH THE OFFICIAL VG SPIRAL...

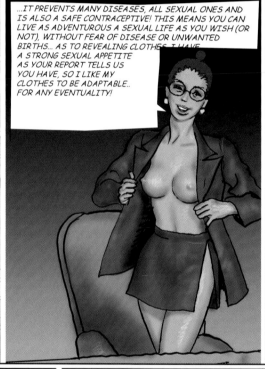

...IT PREVENTS MANY DISEASES, ALL SEXUAL ONES AND IS ALSO A SAFE CONTRACEPTIVE! THIS MEANS YOU CAN LIVE AS ADVENTUROUS A SEXUAL LIFE AS YOU WISH (OR NOT), WITHOUT FEAR OF DISEASE OR UNWANTED BIRTHS... AS TO REVEALING CLOTHES, I HAVE A STRONG SEXUAL APPETITE AS YOUR REPORT TELLS US YOU HAVE, SO I LIKE MY CLOTHES TO BE ADAPTABLE.. FOR ANY EVENTUALITY!

NOW IT'S TIME FOR YOUR SEX EDUCATION CLASS.. I HOPE IT WILL PROVE.. USEFUL!

REPORT?

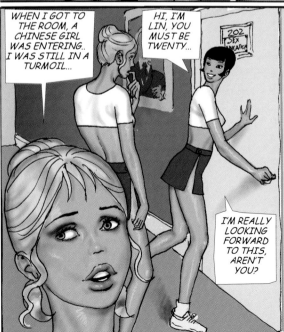

WHEN I GOT TO THE ROOM, A CHINESE GIRL WAS ENTERING.. I WAS STILL IN A TURMOIL...

HI, I'M LIN, YOU MUST BE TWENTY...

I'M REALLY LOOKING FORWARD TO THIS, AREN'T YOU?

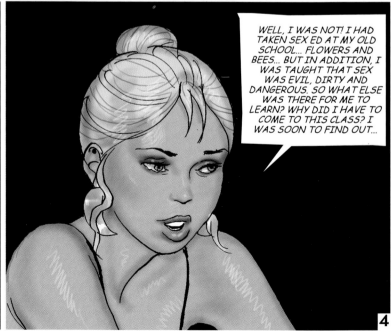

WELL, I WAS NOT! I HAD TAKEN SEX ED AT MY OLD SCHOOL... FLOWERS AND BEES... BUT IN ADDITION, I WAS TAUGHT THAT SEX WAS EVIL, DIRTY AND DANGEROUS. SO WHAT ELSE WAS THERE FOR ME TO LEARN? WHY DID I HAVE TO COME TO THIS CLASS? I WAS SOON TO FIND OUT...

4

MS. PARK TOLD US ABOUT THE VG BREAK-THROUGH.. ABOUT OUR VG SPIRALS, ABOUT THE FIRST SEX REVOLUTION OF THE 60S AND ITS REVIVAL TODAY...

SHE TOLD US OUR TWO DAY ENTRY MEDICAL EXAMI-NATIONS WERE TO DETERMINE OUR SEX DRIVES...

WE WERE BOTH 150%! .. AND NOW WE WOULD HAVE SOME PRACTICAL EXPERIENCE...

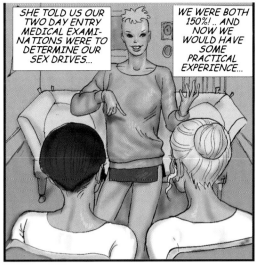

NATURALLY, I DIDN'T BELIEVE HER! BUT SUDDENLY...

THIS IS STEFAN...

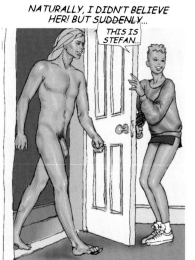

SHE EXPLAINED THAT HE WAS A DEMONSTRATION TOOL.. ABOUT HIS PENIS.. HOW HANDLING IT MAKES IT HARD ENOUGH TO INSERT IN US...

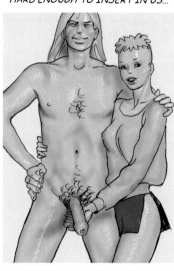

EVERYTHING! OUR EXCITE-MENT GREW...

NOW, WHO GOES FIRST?

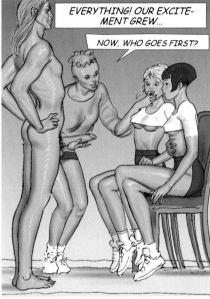

I WILL, MS PARK. I WILL RESPECT MY PARENTS' WISHES.. I AM NOT A VIRGIN, I LOVE SEX AND WOULD LIKE TO BROADEN MY SKILLS IN GIVING AND RECEIVING PLEA-SURE...!

AS I WATCHED, I THOUGHT HOW LITTLE SHE HAD TO LEARN, WHEREAS I... SOON I WAS SO EXCITED THAT, WHEN MS. PARK NOW NUDE REMOVED THE LITTLE CLOTHING I WORE, I HARDLY NOTICED!

AND WHEN HER MOMENT CAME, I WISHED IT WAS ME!!

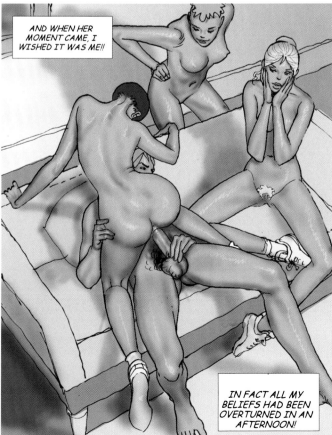

IN FACT ALL MY BELIEFS HAD BEEN OVERTURNED IN AN AFTERNOON!

NOW MY DREAMS, MY FANTASIES WERE IN FRONT OF MY EYES!

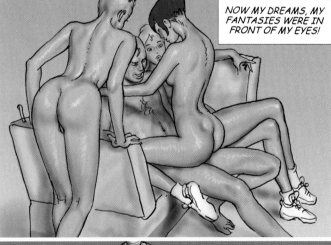

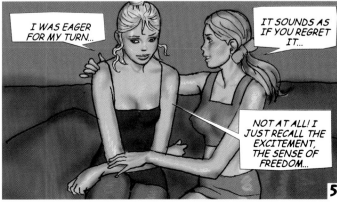

I WAS EAGER FOR MY TURN...

IT SOUNDS AS IF YOU REGRET IT...

NOT AT ALL! I JUST RECALL THE EXCITEMENT, THE SENSE OF FREEDOM...

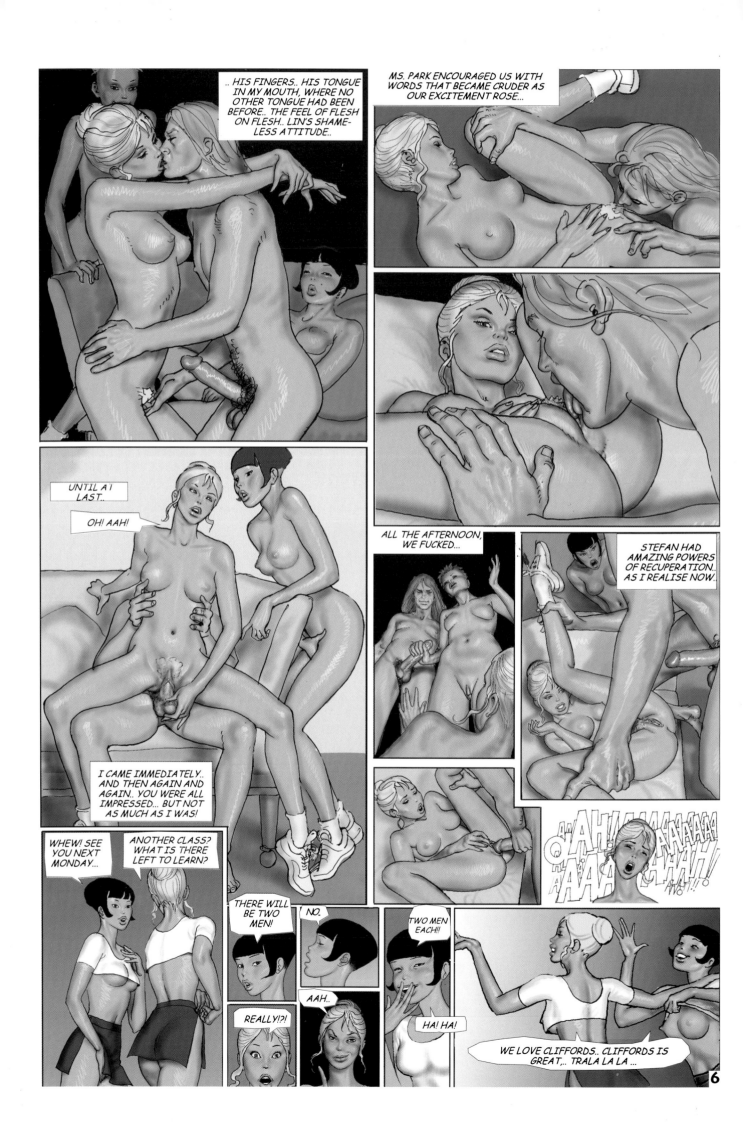

6

THE NEXT EVENING, A SATURDAY WAS A 2 A.M. CURFEW.. YOU TOOK ME INTO TOWN..

I FELT A POWERFUL URGE TO FLAUNT MY NEW FOUND SEMI-NUDITY MORE FROM CURIOSITY AT FIRST...

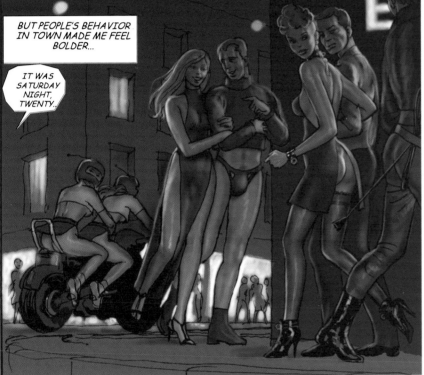

BUT PEOPLE'S BEHAVIOR IN TOWN MADE ME FEEL BOLDER...

IT WAS SATURDAY NIGHT, TWENTY..

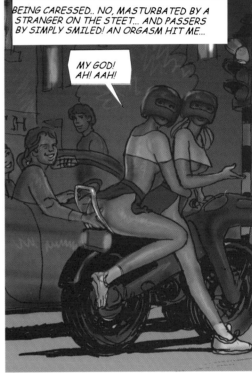

BEING CARESSED.. NO, MASTURBATED BY A STRANGER ON THE STEET... AND PASSERS BY SIMPLY SMILED! AN ORGASM HIT ME...

MY GOD! AH! AAH!

I WAS AMAZED... IF THIS COULD HAPPEN, WHAT ELSE COULD HAPPEN ON THIS MY FIRST NIGHT OF SEXUAL LIBERATION? FOR NOW WE WENT STRAIGHT INTO THIS PLACE CALLED SYBIL...

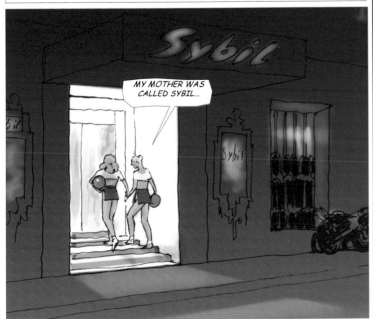

Sybil

MY MOTHER WAS CALLED SYBIL...

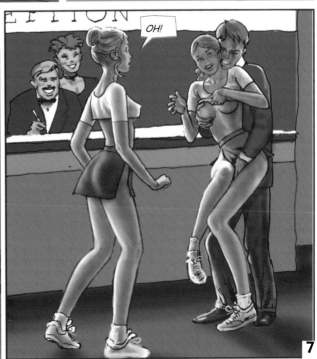

OH!

7

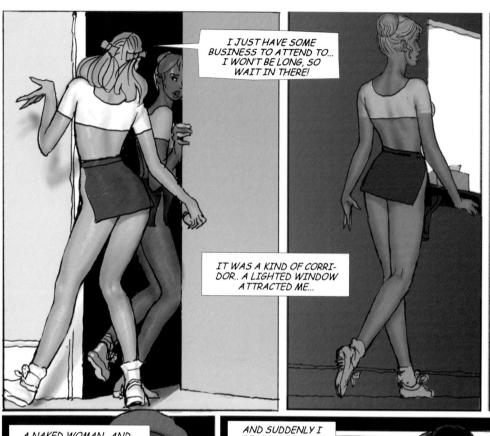

I JUST HAVE SOME BUSINESS TO ATTEND TO... I WON'T BE LONG, SO WAIT IN THERE!

IT WAS A KIND OF CORRIDOR.. A LIGHTED WINDOW ATTRACTED ME...

I WAS TAKEN ABACK..

A NAKED WOMAN.. AND.. NO..! IT COULDN'T BE! IT WAS.. MS PARK!!

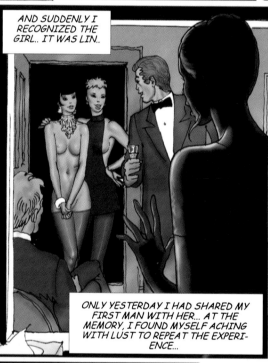

AND SUDDENLY I RECOGNIZED THE GIRL... IT WAS LIN..

ONLY YESTERDAY I HAD SHARED MY FIRST MAN WITH HER... AT THE MEMORY, I FOUND MYSELF ACHING WITH LUST TO REPEAT THE EXPERIENCE...

LONGINGLY I WATCHED AS MS PARK OFFERED MY NEW FRIEND TO THESE MEN..

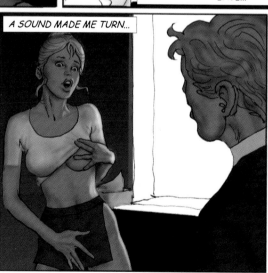

A SOUND MADE ME TURN...

SIMULTANEOUSLY, I FELT A HAND ON MY SHOULDER!

8

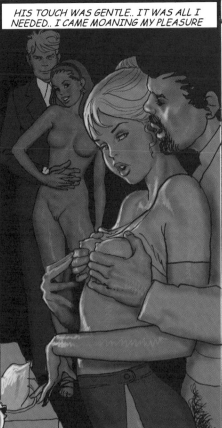

HIS TOUCH WAS GENTLE.. IT WAS ALL I NEEDED.. I CAME MOANING MY PLEASURE

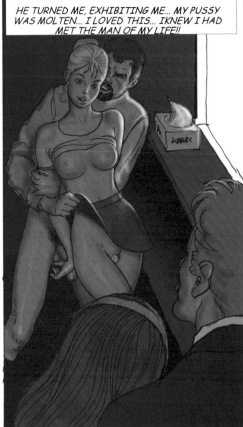

HE TURNED ME, EXHIBITING ME... MY PUSSY WAS MOLTEN... I LOVED THIS... I KNEW I HAD MET THE MAN OF MY LIFE!!

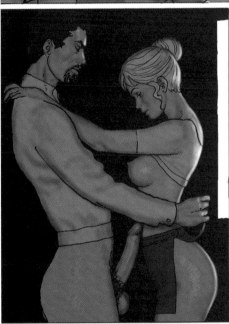

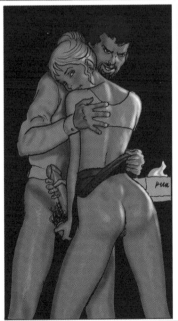

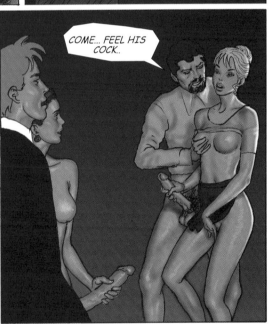

COME... FEEL HIS COCK..

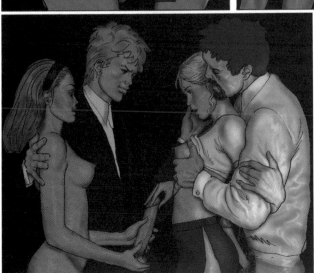

SUDDENLY..

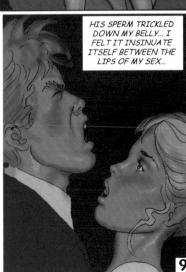

HIS SPERM TRICKLED DOWN MY BELLY... I FELT IT INSINUATE ITSELF BETWEEN THE LIPS OF MY SEX...

9

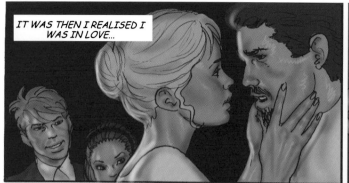

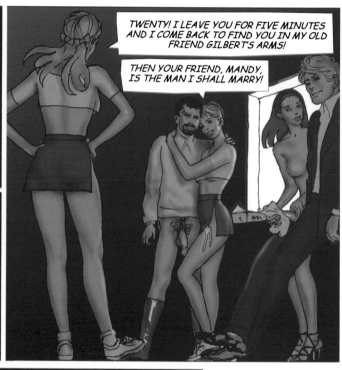

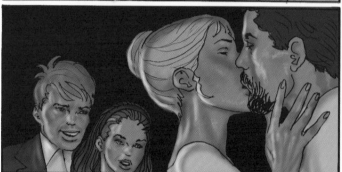

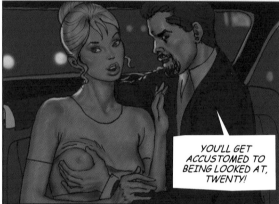

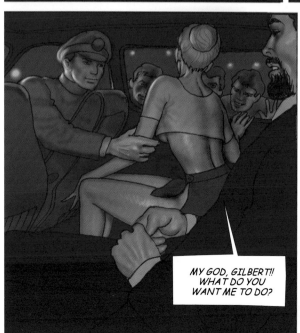

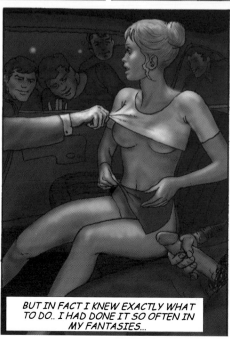

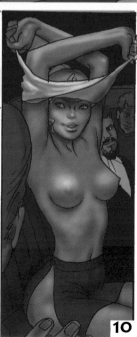

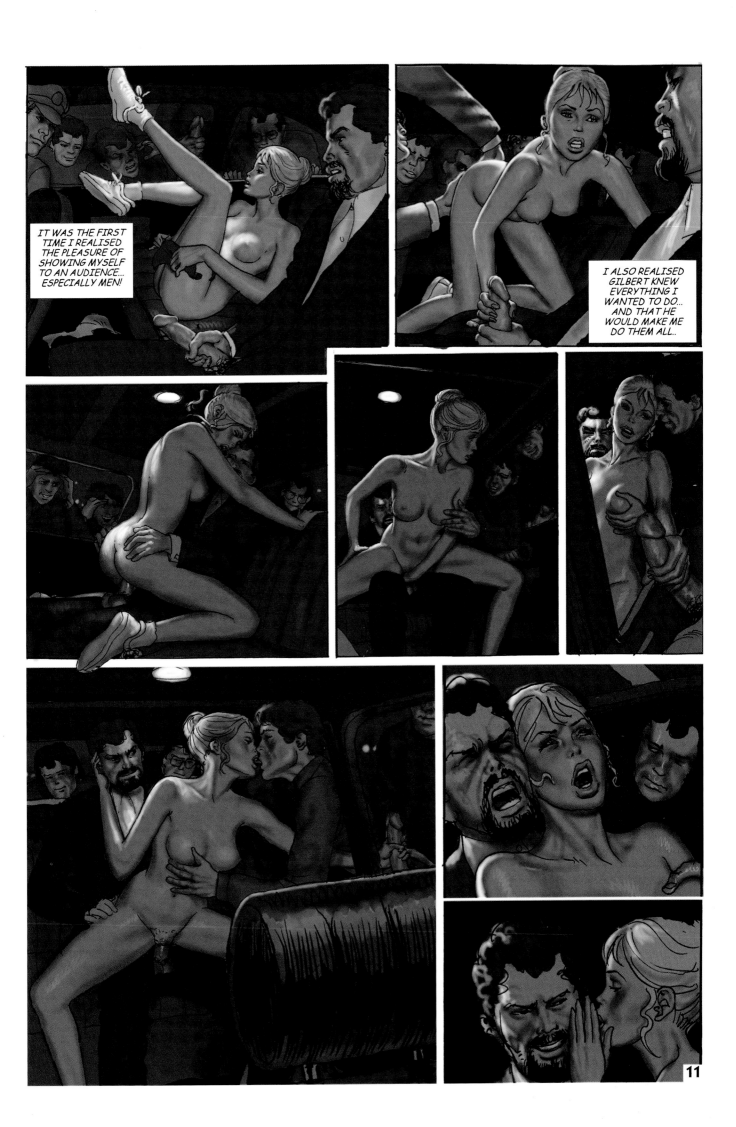

IT WAS THE FIRST TIME I REALISED THE PLEASURE OF SHOWING MYSELF TO AN AUDIENCE... ESPECIALLY MEN!

I ALSO REALISED GILBERT KNEW EVERYTHING I WANTED TO DO... AND THAT HE WOULD MAKE ME DO THEM ALL..

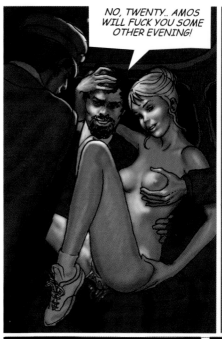

NO, TWENTY.. AMOS WILL FUCK YOU SOME OTHER EVENING!

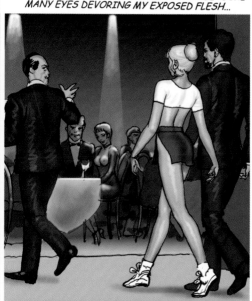

THE WOMEN IN THE RESTAURANT WERE AS LIGHTLY DRESSED AS ME... I FELT WITH PLEASURE MANY EYES DEVOURING MY EXPOSED FLESH...

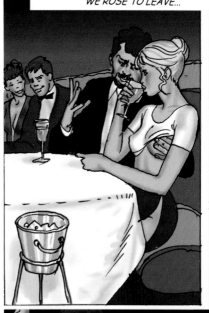

OVER DINNER, WE TALKED... BUT WHEN WE ROSE TO LEAVE...

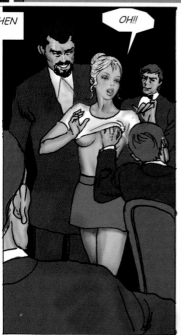

OH!!!

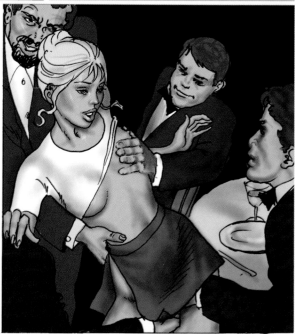

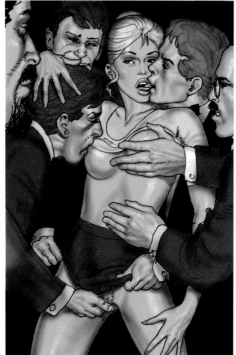

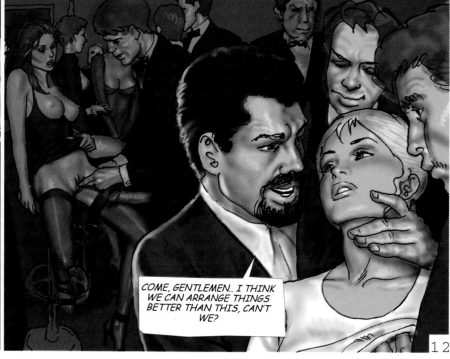

COME, GENTLEMEN.. I THINK WE CAN ARRANGE THINGS BETTER THAN THIS, CAN'T WE?

12

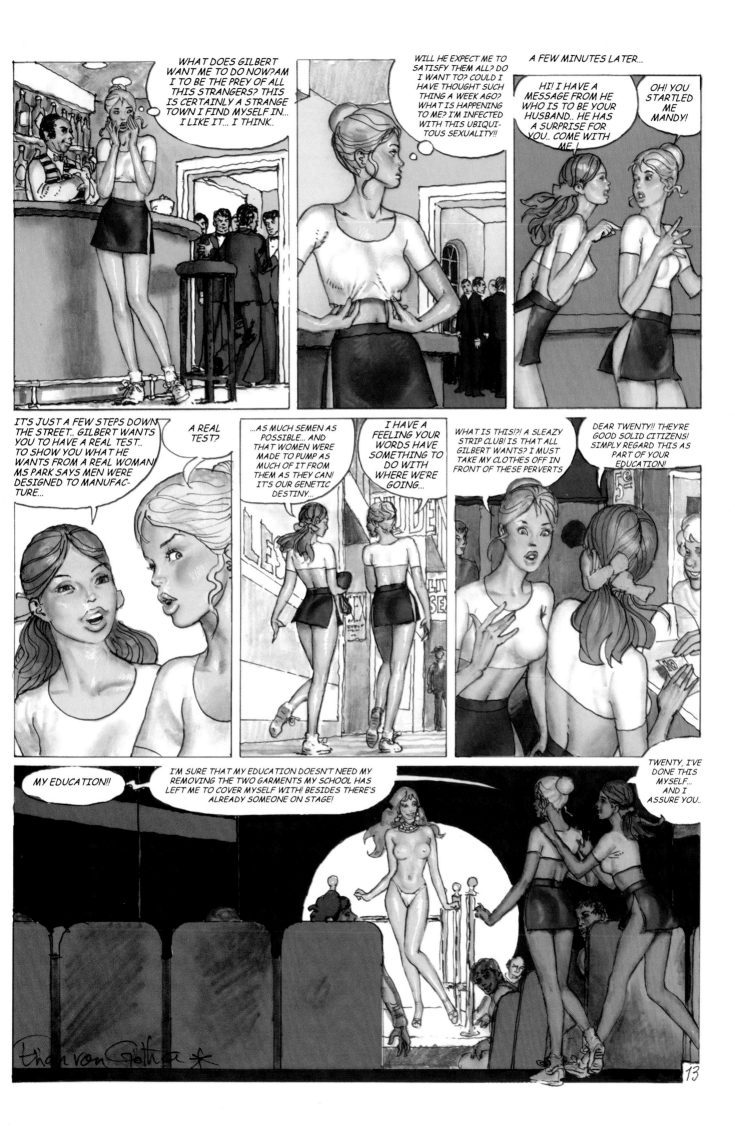

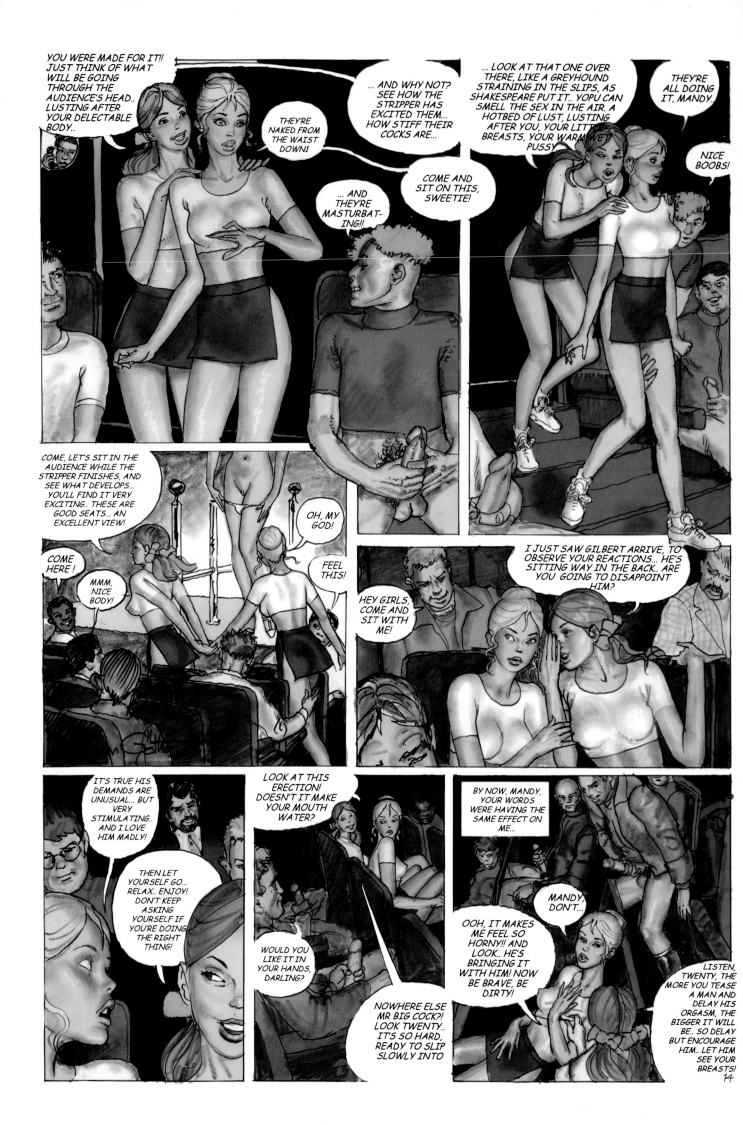

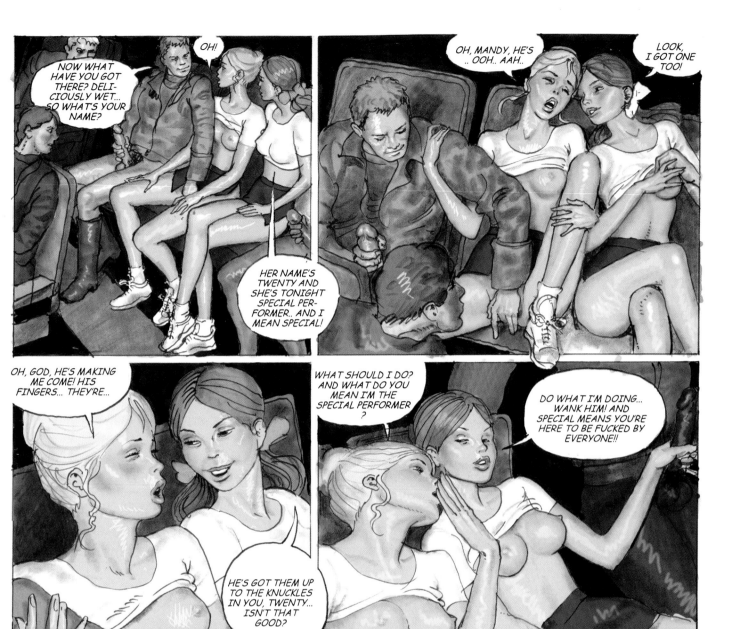

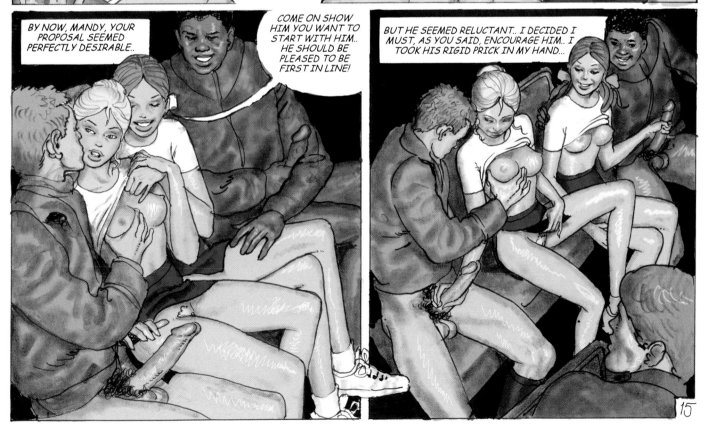

15

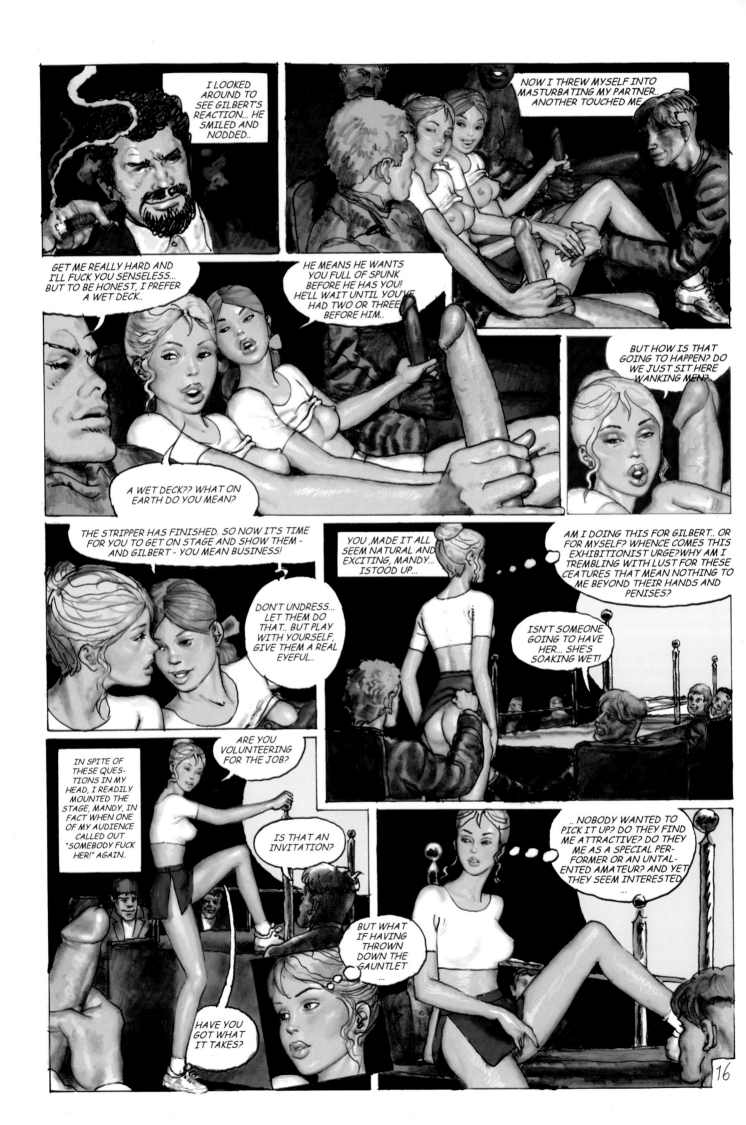

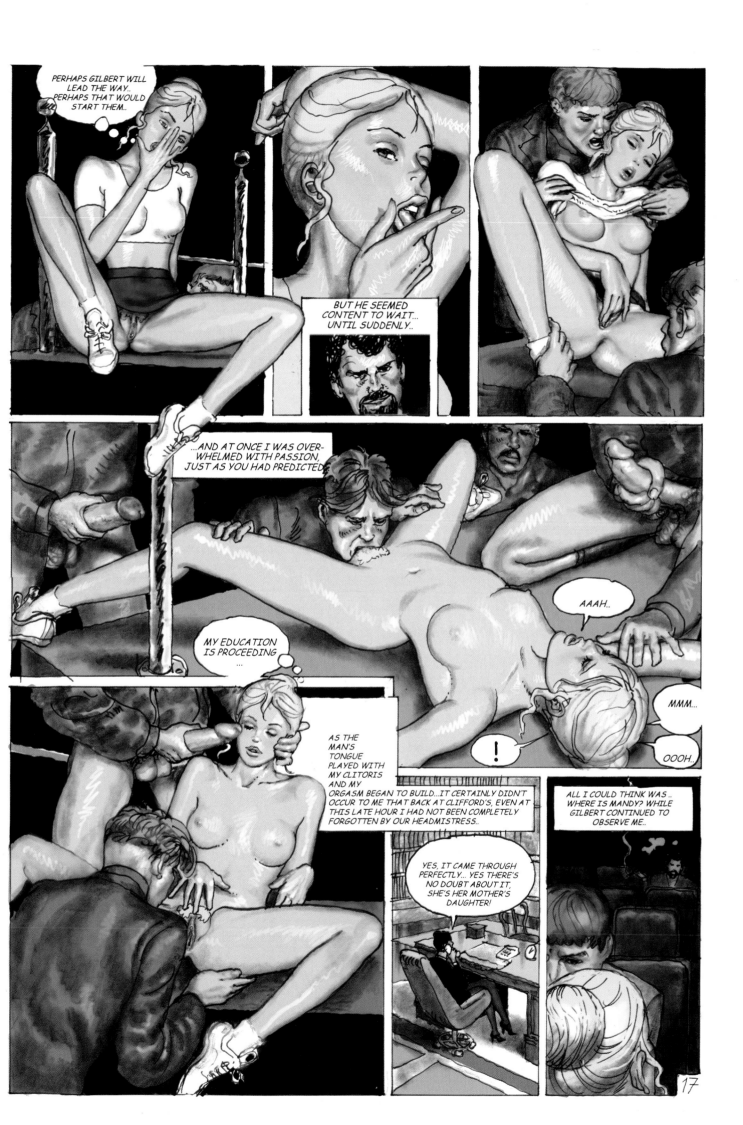

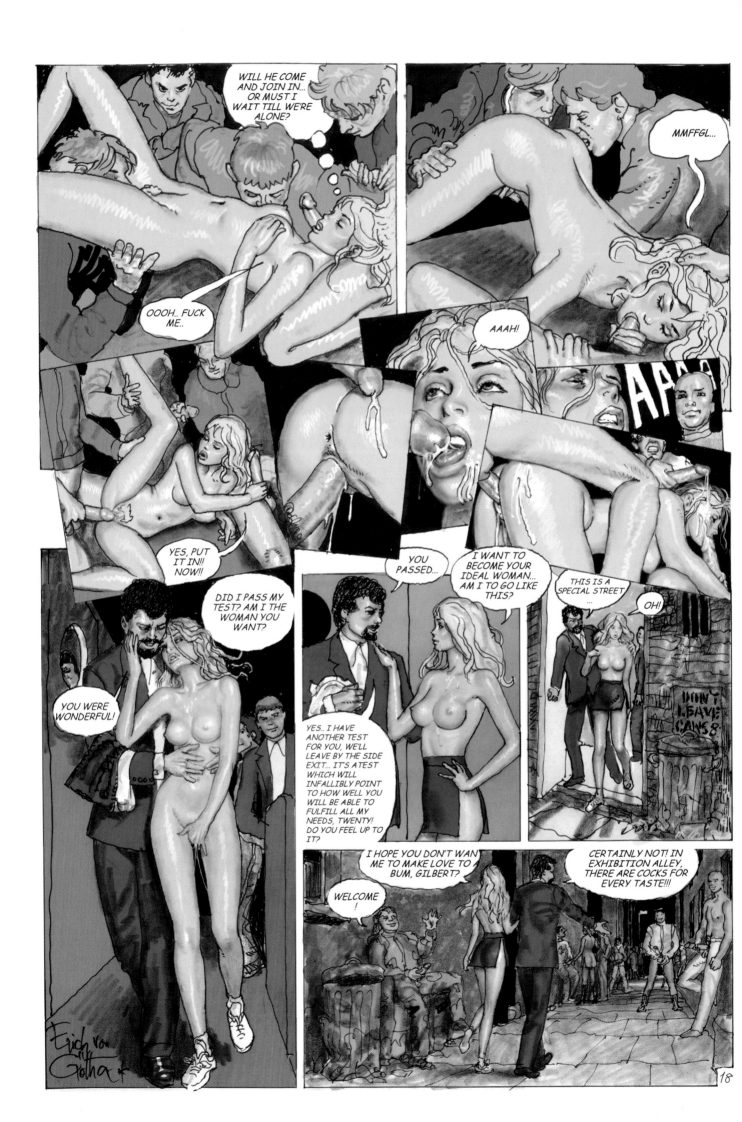

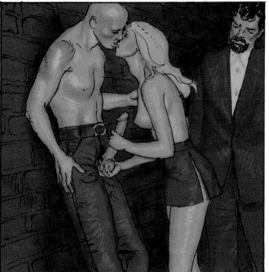

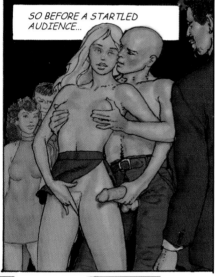

SO BEFORE A STARTLED AUDIENCE...

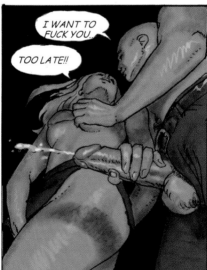

I WANT TO FUCK YOU...

TOO LATE!!

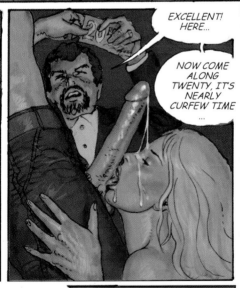

EXCELLENT! HERE...

NOW COME ALONG TWENTY, IT'S NEARLY CURFEW TIME ...

AND DID I PASS MY EXAMS WITH FLYING COLORS?

WITH THE HONORS OF WAR!!

TWENTY, WILL YOU MARRY ME?

NATURALLY..

UNLESS YOU KNOW ANOTHER MAN WHO COULD HANDLE A WOMAN LIKE ME?

I LOVE YOU ...

WHO THE GODS DESTROY THEY SAY THEY FIRST DRIVE MAD.. I WAS MAD ABOUT GILBERT...

19

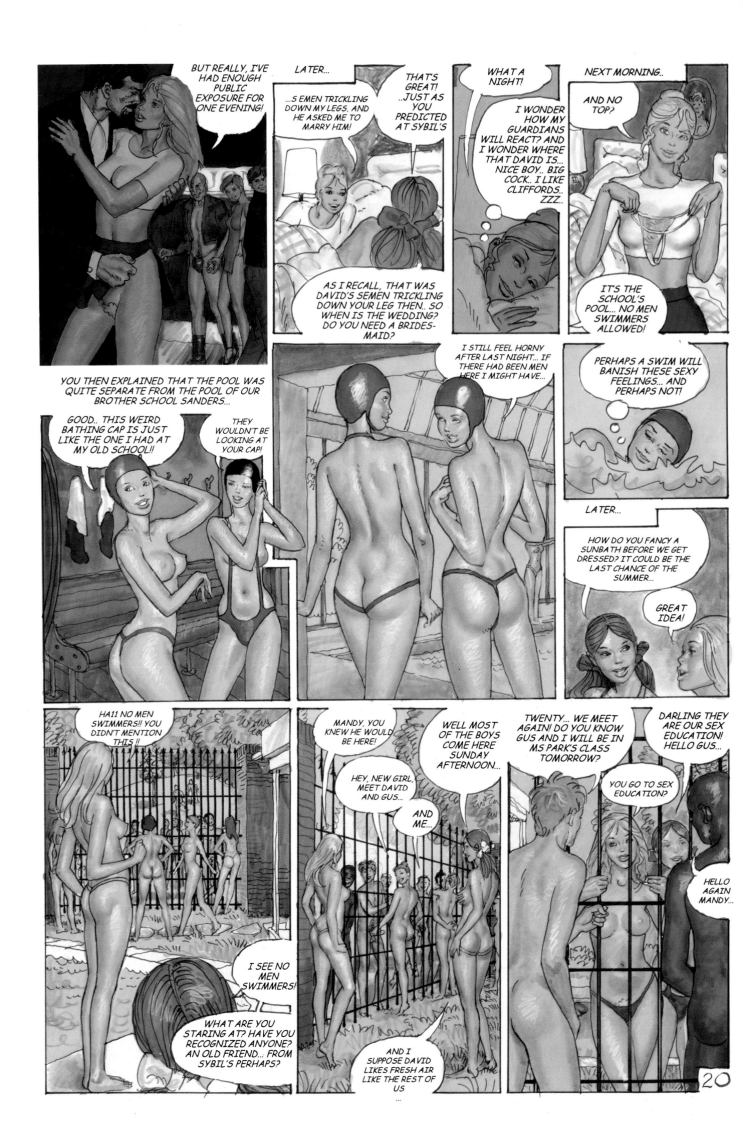

DAVID MS PARK WOULDN'T APPROVE...

YOU'RE RIGHT GUS...

WE MUST PUT OFF THE PLEASURE UNTIL TOMORROW... HEY DARREN, COME HERE!

BUT...

AREN'T WE TO BE INTRO-DUCED PROPERLY?

TWENTY, MAY I INTROD

WOW! NOW THAT'S WHAT I CALL A REAL SLUT!

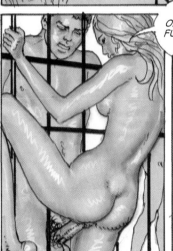

OH GOD! FUCK ME!

YES!!

Y-E-E-SS!

AAAAAA

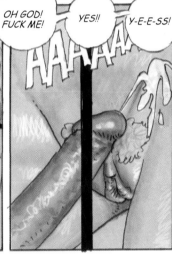

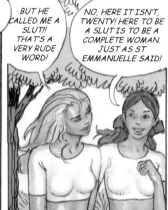

BUT HE CALLED ME A SLUT!! THAT'S A VERY RUDE WORD!

NO, HERE IT ISN'T, TWENTY! HERE TO BE A SLUT IS TO BE A COMPLETE WOMAN. JUST AS ST EMMANUELLE SAID!

FOR YOUR INFORMATION SHE WAS THE FINEST PHILOSOPHER OF HER TIME.. SHE WROTE THE HANDBOOKS OF THE FIRSY SEXUAL REVOLUTION. YOU ALREADY PRACTISE WHAT SHE PREACHED! HAVE YOU EVER SEEN AN EROTIC FILM? OR A SEX DVD? OR AN ORGY ON OLD FASHIONED VIDEO? COME... YOU HAVE THINGS TO LEARN.. COME!

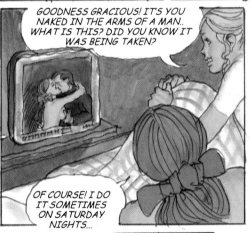

GOODNESS GRACIOUS! IT'S YOU NAKED IN THE ARMS OF A MAN.. WHAT IS THIS? DID YOU KNOW IT WAS BEING TAKEN?

OF COURSE! I DO IT SOMETIMES ON SATURDAY NIGHTS...

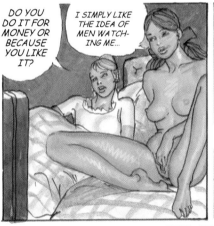

DO YOU DO IT FOR MONEY OR BECAUSE YOU LIKE IT?

I SIMPLY LIKE THE IDEA OF MEN WATCH-ING ME...

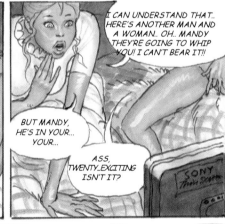

I CAN UNDERSTAND THAT.. HERE'S ANOTHER MAN AND A WOMAN.. OH.. MANDY THEY'RE GOING TO WHIP YOU! I CAN'T BEAR IT!!

BUT MANDY, HE'S IN YOUR... YOUR...

ASS, TWENTY..EXCITING ISN'T IT?

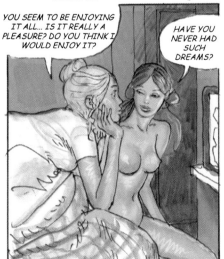

YOU SEEM TO BE ENJOYING IT ALL... IS IT REALLY A PLEASURE? DO YOU THINK I WOULD ENJOY IT?

HAVE YOU NEVER HAD SUCH DREAMS?

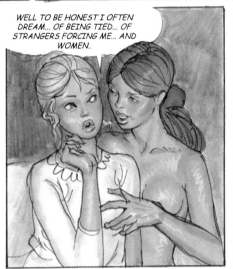

WELL TO BE HONEST I OFTEN DREAM... OF BEING TIED... OF STRANGERS FORCING ME... AND WOMEN..

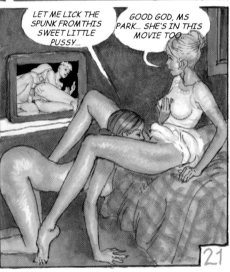

LET ME LICK THE SPUNK FROM THIS SWEET LITTLE PUSSY...

GOOD GOD, MS PARK... SHE'S IN THIS MOVIE TOO.

21

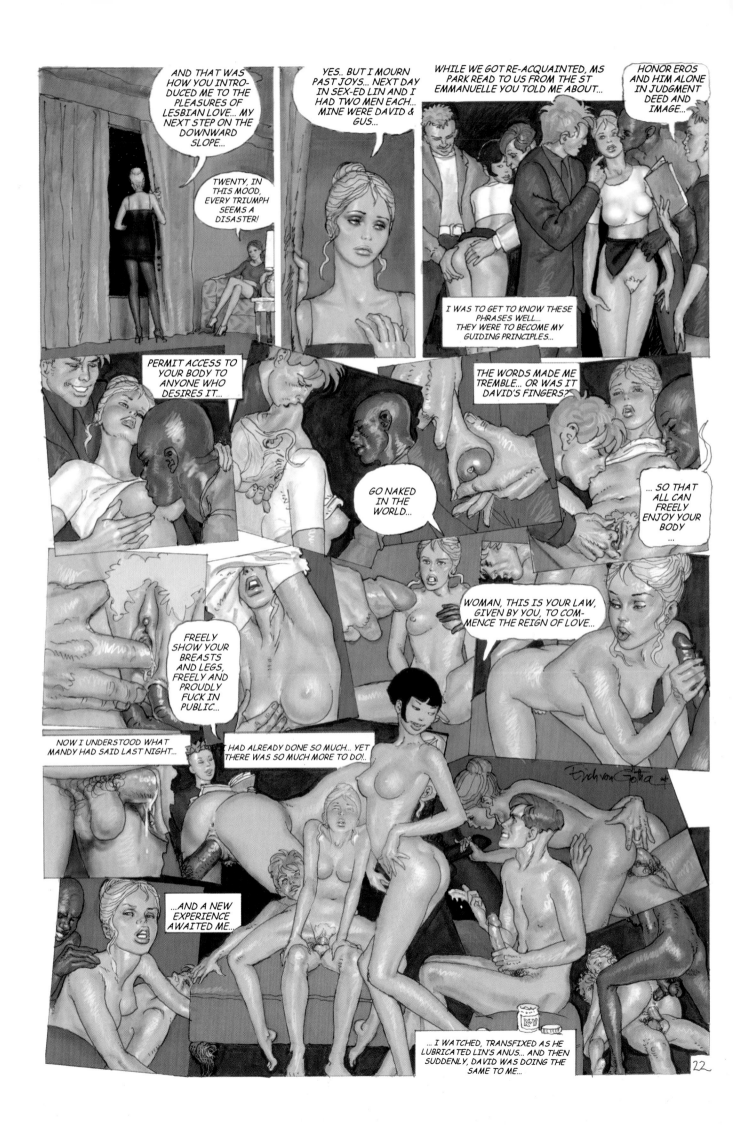

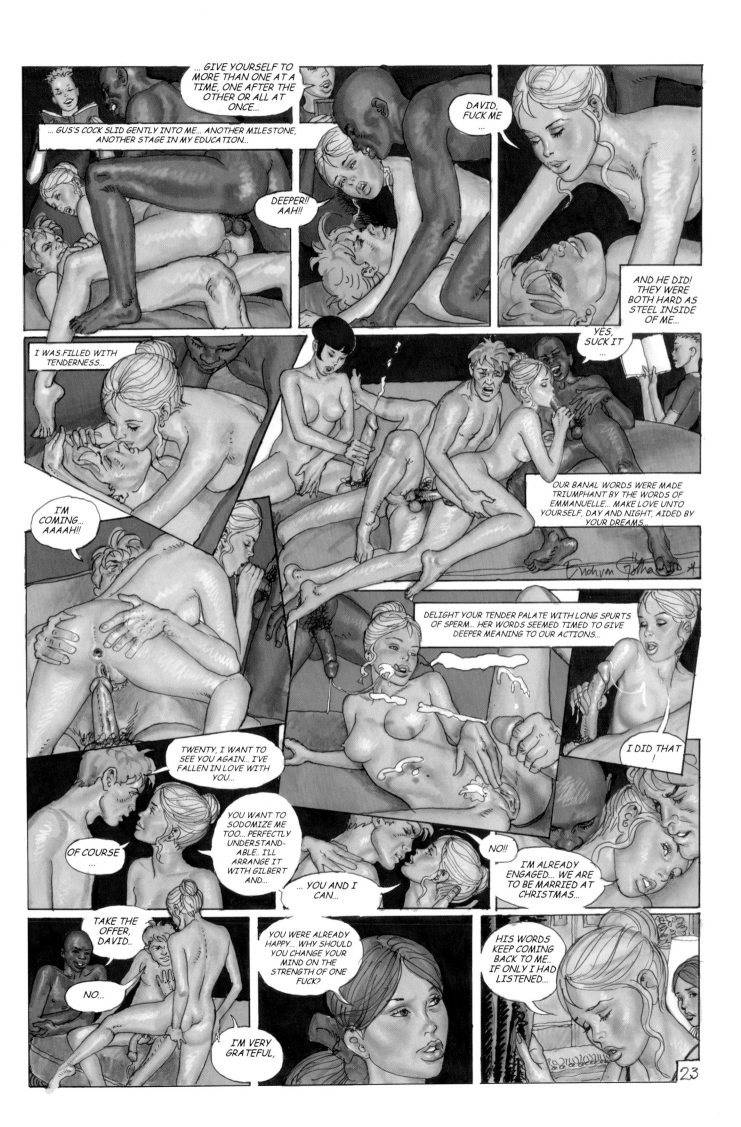

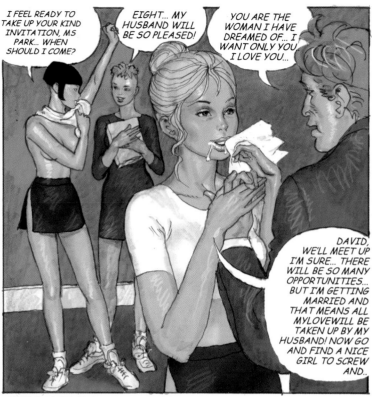

I FEEL READY TO TAKE UP YOUR KIND INVITATION, MS PARK... WHEN SHOULD I COME?

EIGHT... MY HUSBAND WILL BE SO PLEASED!

YOU ARE THE WOMAN I HAVE DREAMED OF... I WANT ONLY YOU... I LOVE YOU...

DAVID, WE'LL MEET UP I'M SURE... THERE WILL BE SO MANY OPPORTUNITIES... BUT I'M GETTING MARRIED AND THAT MEANS ALL MY LOVE WILL BE TAKEN UP BY MY HUSBAND! NOW GO AND FIND A NICE GIRL TO SCREW AND..

TWENTY, LISTEN... I MUST SAY THIS TO YOU... ALL IS NOT AS IT SEEMS!!

MANDY, I SHOULD HAVE LISTENED, ASKED HIM WHAT HIS WORDS MEANT...

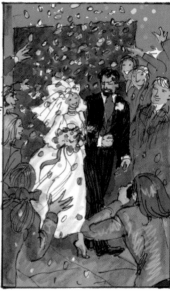

IF I HAD LISTENED AND UNDERSTOOD, MANDY, PERHAPS I WOULDN'T HAVE TAKEN GILBERT TO SEE MY GUARDIANS... THEY WOULDN'T HAVE GOT OON SO WELL... AND WE WOULDN'T HAVE MARRIED ON A FINE COLD DECEMBER DAY...

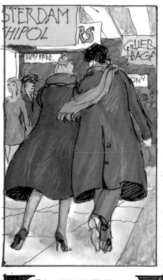

PERHAPS WE WOULDN'T HAVE GONE TO AMSTERDAM FOR OUR HONEYMOON...

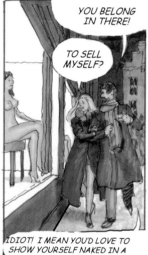

YOU BELONG IN THERE!

TO SELL MYSELF?

IDIOT! I MEAN YOU'D LOVE TO SHOW YOURSELF NAKED IN A SHOP WINDOW...

OR STROLLED ABOUT HAND IN HAND IN THE RED LIGHT DISTRICT...

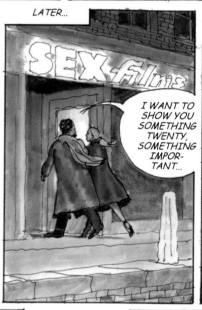

LATER...

I WANT TO SHOW YOU SOMETHING TWENTY, SOMETHING IMPOR- TANT...

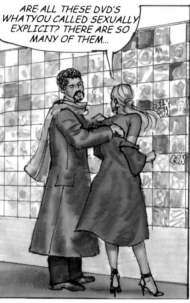

ARE ALL THESE DVD'S WHAT YOU CALLED SEXUALLY EXPLICIT? THERE ARE SO MANY OF THEM...

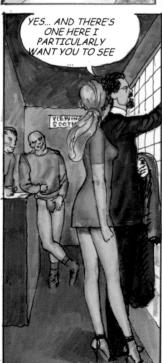

YES... AND THERE'S ONE HERE I PARTICULARLY WANT YOU TO SEE ...

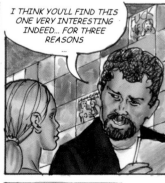

I THINK YOU'LL FIND THIS ONE VERY INTERESTING INDEED... FOR THREE REASONS ...

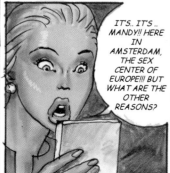

IT'S.. IT'S .. MANDY!! HERE IN AMSTERDAM, THE SEX CENTER OF EUROPE!!! BUT WHAT ARE THE OTHER REASONS?

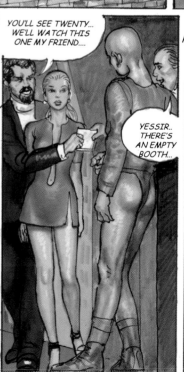

YOU'LL SEE TWENTY... WE'LL WATCH THIS ONE MY FRIEND....

THAT MAN KEEPS STARING AT ME... HE MAKES ME FEEL...

YESSIR.. THERE'S AN EMPTY BOOTH...

THAT MAN KEEPS STARING AT ME... HE MAKES ME FEEL...

... BUT THE OTHER REASONS THIS FILM WILL INTEREST YOU ARE...

24

ARE YOU SURE HE'S NOT GOING TO COME IN?

DO YOU WANT HIM TO? SHALL I GO AND GET HIM? I'M SURE HE'D BE DELIGHTED!

NO!! HE LOOKS AT ME AS IF HE KNOWS ME... BUT I DON'T KNOW HIM...

I JUST CAN'T PUT MY FINGER ON IT... SOMETHING'S WRONG... BUT NOW SHALL WE WATCH MANDY'S VIDEO?..

... IN THE STRIP CLUB!! HOW ON EARTH..?

AND THIS IS ON OPEN SALE?

I WAS TELLING YOU WHY YOU'LL FIND THIS FILM INTERESTING... IT'S NOT JUST THAT MANDY'S IN IT.. IT ALSO STARS SOMEONE ELSE...

MY GOD! IT'S ME !!

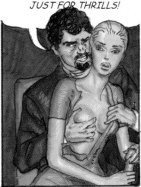

IT'S NORMAL! MANY PEOPLE VIDEO THEMSELVES.. FOR THE MONEY BUT OFTEN JUST FOR THRILLS!

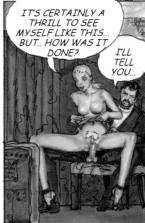

IT'S CERTAINLY A THRILL TO SEE MYSELF LIKE THIS... BUT.. HOW WAS IT DONE?

I'LL TELL YOU...

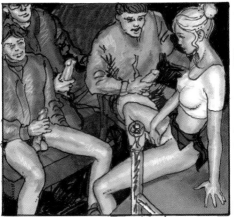

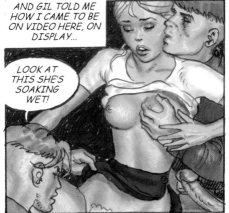

AND GIL TOLD ME HOW I CAME TO BE ON VIDEO HERE, ON DISPLAY...

LOOK AT THIS SHE'S SOAKING WET!

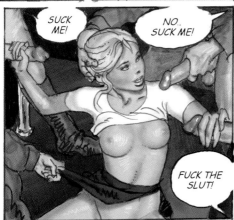

SUCK ME!

NO.. SUCK ME!

FUCK THE SLUT!

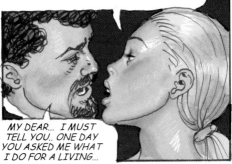

THOSE WORDS.. "FUCK THE SLUT" THEY IRRITATED A NERVE IN MY BRAIN... SO COARSE! SO RUDE! IT EXCITED ME.. TO BE TREATED LIKE A WHORE...

MY DEAR... I MUST TELL YOU.. ONE DAY YOU ASKED ME WHAT I DO FOR A LIVING...

I TOLD YOU BUSINESS, JUST BUSINESS... WELL THIS IS MY BUSINESS... I MAKE PORNO FILMS... BIG ONES MAIN FEATURE FILMS.. I PRODUCE AND DIRECT THEM. NOT FILMS LIKE THESE.. AND I TRY TO FIND BEAUTIFUL WOMEN AND POTENT MEN TO MAKE MY FILMS SUPERB...

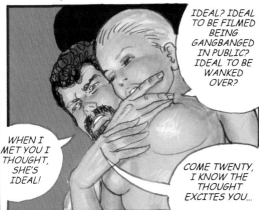

IDEAL? IDEAL TO BE FILMED BEING GANGBANGED IN PUBLIC? IDEAL TO BE WANKED OVER?

WHEN I MET YOU I THOUGHT, SHE'S IDEAL!

COME TWENTY, I KNOW THE THOUGHT EXCITES YOU...

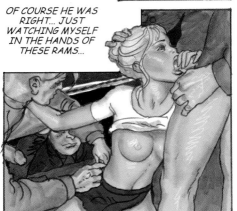

OF COURSE HE WAS RIGHT... JUST WATCHING MYSELF IN THE HANDS OF THESE RAMS...

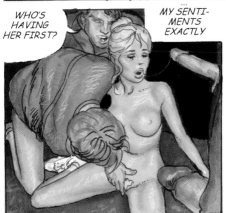

WHO'S HAVING HER FIRST?

MY SENTI-MENTS EXACTLY

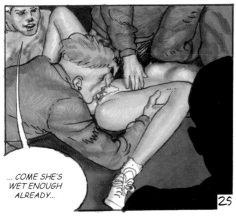

... COME SHE'S WET ENOUGH ALREADY...

25

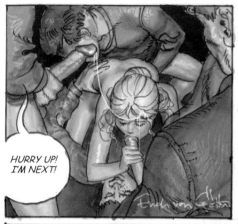

HURRY UP! I'M NEXT!

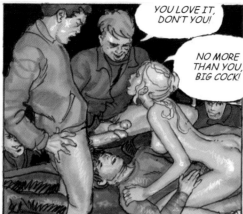

YOU LOVE IT, DON'T YOU!

NO MORE THAN YOU, BIG COCK!

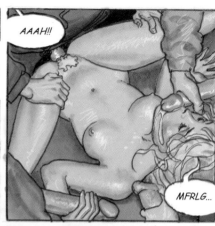

AAAH!!

MFRLG...

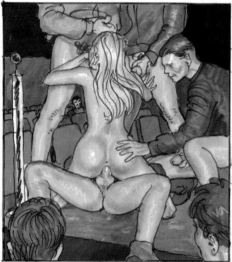

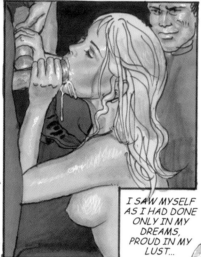

I SAW MYSELF AS I HAD DONE ONLY IN MY DREAMS, PROUD IN MY LUST...

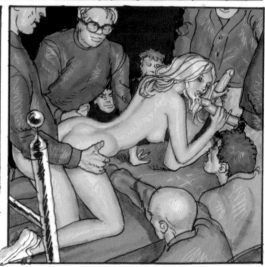

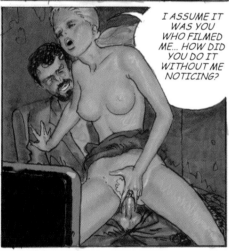

I ASSUME IT WAS YOU WHO FILMED ME... HOW DID YOU DO IT WITHOUT ME NOTICING?

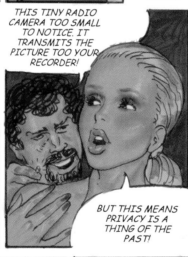

THIS TINY RADIO CAMERA TOO SMALL TO NOTICE. IT TRANSMITS THE PICTURE TOO YOUR RECORDER!

BUT THIS MEANS PRIVACY IS A THING OF THE PAST!

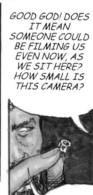

GOOD GOD! DOES IT MEAN SOMEONE COULD BE FILMING US EVEN NOW, AS WE SIT HERE? HOW SMALL IS THIS CAMERA?

THIS SMALL TWENTY...

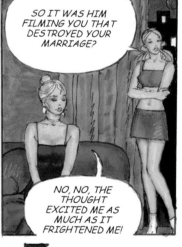

SO IT WAS HIM FILMING YOU THAT DESTROYED YOUR MARRIAGE?

NO, NO, THE THOUGHT EXCITED ME AS MUCH AS IT FRIGHTENED ME!

PATIENCE, MANDY! WE WENT ON, WATCHING THE FILM, WHEN SUDDENLY...

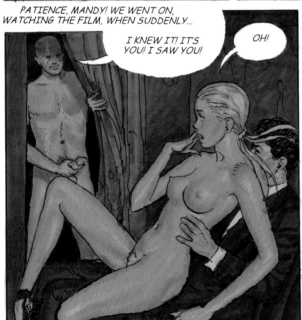

I KNEW IT! IT'S YOU! I SAW YOU!

OH!

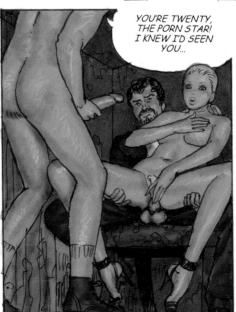

YOU'RE TWENTY, THE PORN STAR! I KNEW I'D SEEN YOU...

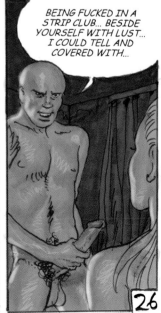

BEING FUCKED IN A STRIP CLUB... BESIDE YOURSELF WITH LUST... I COULD TELL AND COVERED WITH...

26

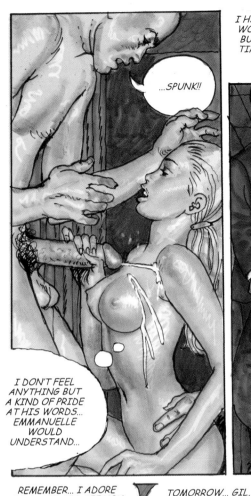

...SPUNK!!

I DON'T FEEL ANYTHING BUT A KIND OF PRIDE AT HIS WORDS... EMMANUELLE WOULD UNDERSTAND...

I HAD BEGUN TO HOPE THIS INTRUSION WOULD LEAD TO MORE ROBUST ACTION BUT THE MAN WAS FINISHED FOR THE TIME BEING... AND GILBERT HAD OTHER FISH TO FRY THAT EVENING...

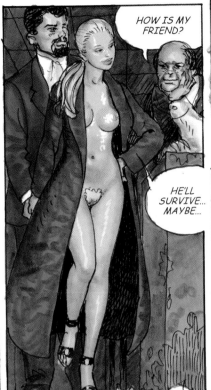

HOW IS MY FRIEND?

HE'LL SURVIVE... MAYBE...

I ASKED GILBERT... DID YOU MARRY ME TO ENSURE I WOULD BE YOUR NEXT PORN STAR? I MARRIED YOU BECAUSE I LOVE YOU, HE SAID... I WANT TO SPEND THE REST OF MY LIFE WITH YOU!

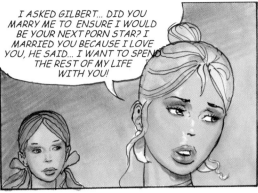

I WAS REASSURED... AND WE RESUMED OUR HONEYMOON. BUT WHEN WE GOT BACK TO THE SCHOOL, I FELT A SUDDEN SENSE OF PARTING...

REMEMBER... I ADORE YOU... AND I'LL SEE YOU ON SATURDAY... WHEN IS YOUR NEXT SEX CLASS?

TOMORROW... GIL, YOU DON'T FEEL JEALOUS ABOUT ME SPENDING THE AFTERNOON WITH TWO HORNY YOUNG MEN?

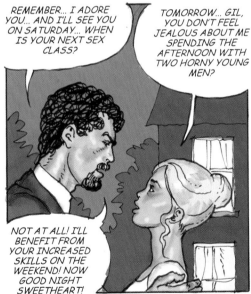

NOT AT ALL! I'LL BENEFIT FROM YOUR INCREASED SKILLS ON THE WEEKEND! NOW GOOD NIGHT SWEETHEART!

SO, HOW WAS YOUR HONEYMOON?

DID HE DEBAUCH YOU?, DID HE TAKE YOU TO DENS OF INIQUITY?

WELL OF COURSE HE DID!! HE SAYS IT'S NORMAL THESE DAYS!

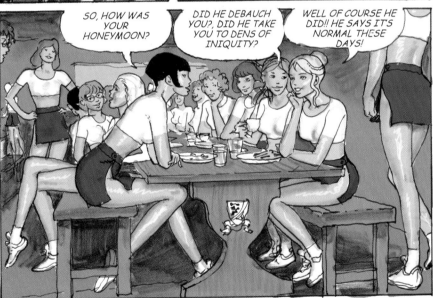

WELL OF COURSE IT IS! BUT DO TELL US THE DETAILS...

I CAN SEE I'LL HAVE TO! BUT WHERE SHOULD I START? SHOULD I TELL YOU ABOUT THE RIJKSMUSEUM? OR THE CANALS?

OR SHOULD IN START WITH US BUYING ME OUTRAGEOUSLY EXHIBITIONIST CLOTHES?

... AND HOW HE TOOK ME TO THIS STRANGE CLUB...

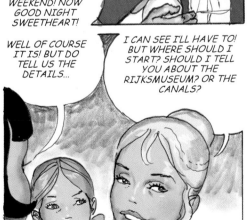

27

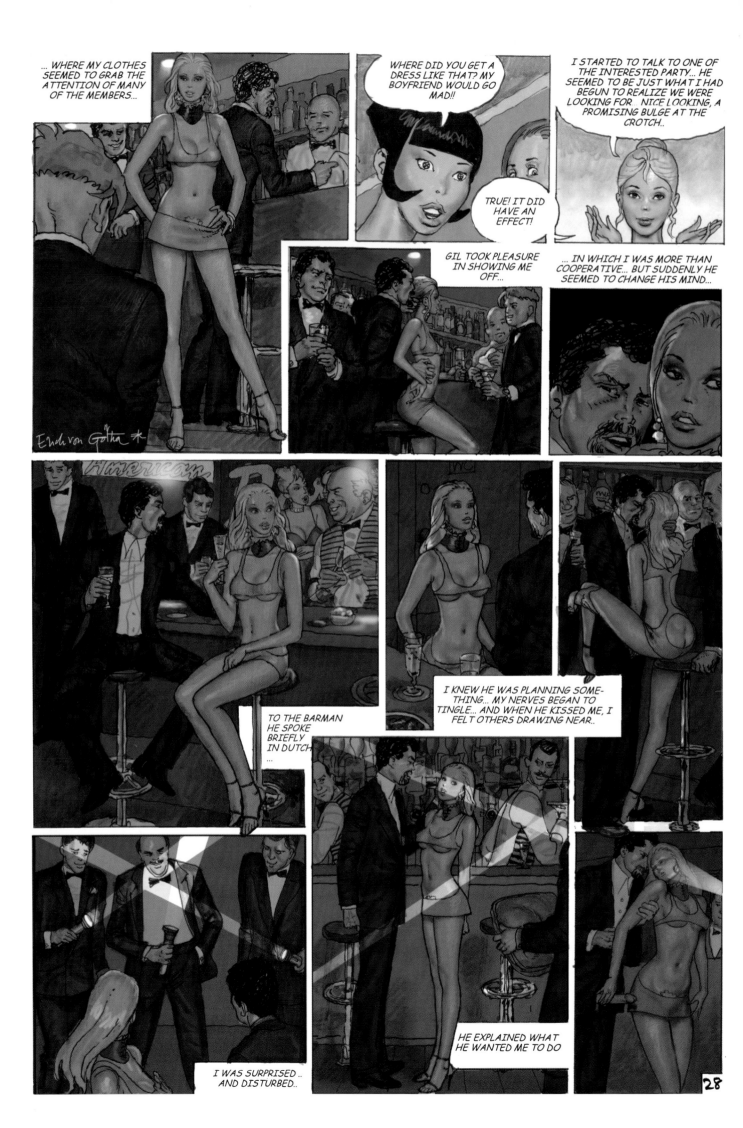

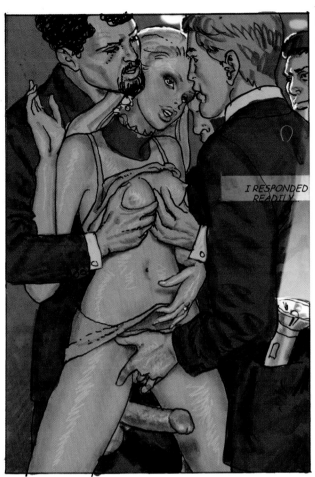

I RESPONDED READILY...

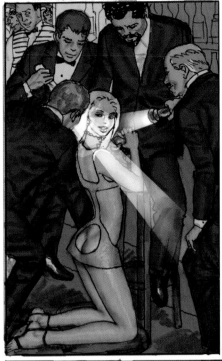

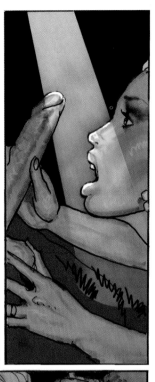

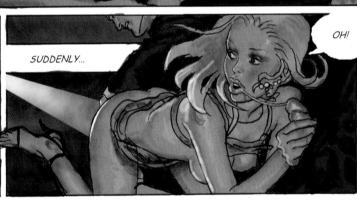

SUDDENLY...

OH!

COME TWENTY...

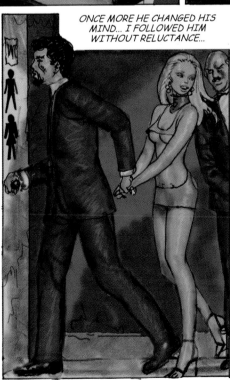

ONCE MORE HE CHANGED HIS MIND... I FOLLOWED HIM WITHOUT RELUCTANCE...

THIS IS A VOYEUR'S PARADISE.. AND AN EXHIBITIONIST'S... DON'T YOU AGREE?

I HAD TO ADMIT... IT WAS...

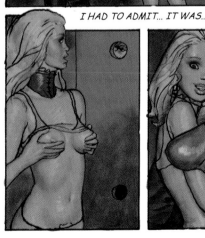

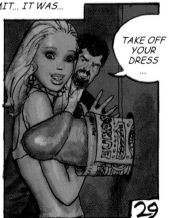

TAKE OFF YOUR DRESS ...

29

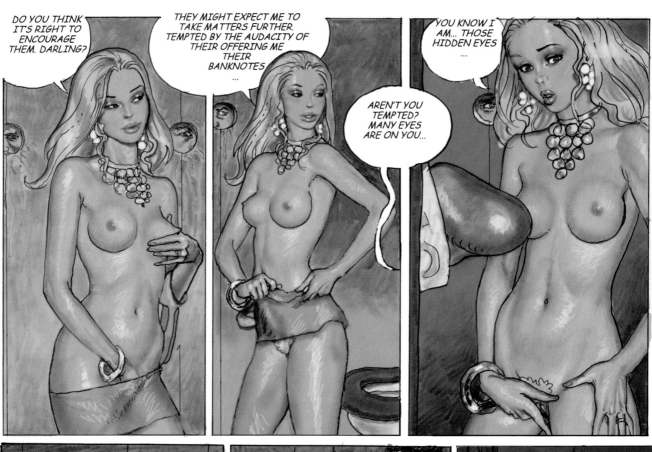

DO YOU THINK
IT'S RIGHT TO
ENCOURAGE
THEM, DARLING?

THEY MIGHT EXPECT ME TO
TAKE MATTERS FURTHER,
TEMPTED BY THE AUDACITY OF
THEIR OFFERING ME
THEIR
BANKNOTES
...

AREN'T YOU
TEMPTED?
MANY EYES
ARE ON YOU...

YOU KNOW I
AM... THOSE
HIDDEN EYES
...

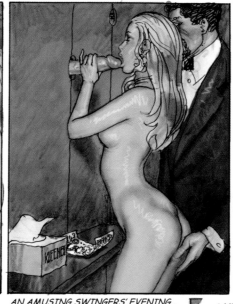

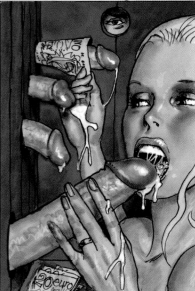

LATER, WE LEFT OUR
HOTEL EN ROUTE TO
A BORDEL...

A
WHAT?

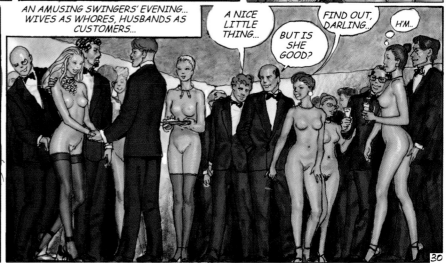

AN AMUSING SWINGERS' EVENING...
WIVES AS WHORES, HUSBANDS AS
CUSTOMERS...

A NICE
LITTLE
THING...

BUT IS
SHE
GOOD?

FIND OUT,
DARLING...

H'M...

30

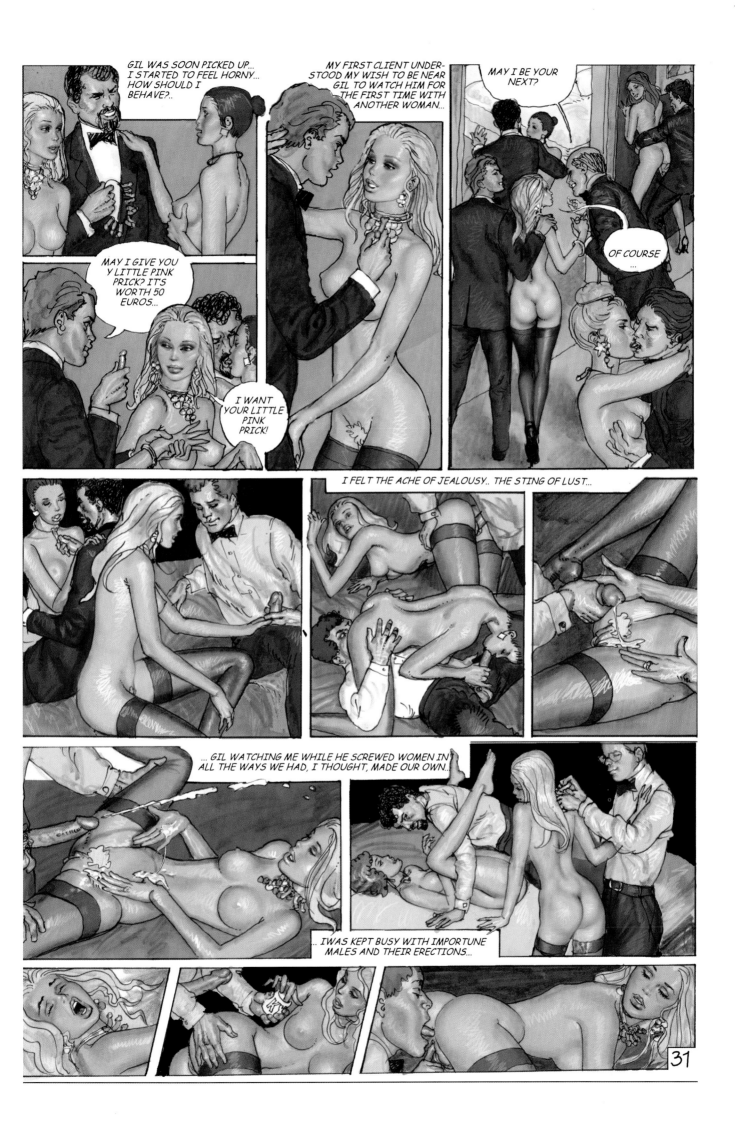

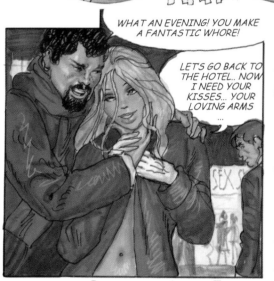

WHAT AN EVENING! YOU MAKE A FANTASTIC WHORE!

LET'S GO BACK TO THE HOTEL.. NOW I NEED YOUR KISSES... YOUR LOVING ARMS ...

BUT YOU ENJOYED IT ...HOW MANY DID YOU HAVE?

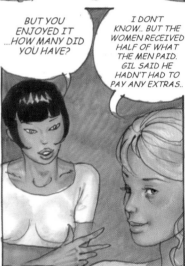

I DON'T KNOW.. BUT THE WOMEN RECEIVED HALF OF WHAT THE MEN PAID. GIL SAID HE HADN'T HAD TO PAY ANY EXTRAS..

SO I MUST HAVE HAD QUITE A LOT! I ENJOYED MYSELF BUT NOW I'M TIRED... GOODNIGHT!

WE CAN GUESS WHY! TOO MANY PRICKS!

AND ALL OF THEM PINK!

NEXT DAY... TWO MEN EACH AGAIN!

ONLY TWO! I GUESS THAT'S BETTER THAN NONE...

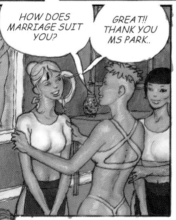

HOW DOES MARRIAGE SUIT YOU?

GREAT!! THANK YOU MS PARK..

I'M LUCKY... GILBERT IS VERY KEEN THAT I SHOULD CONTINUE YOUR CLASSES... HE'S NOT AT ALL JEALOUS!

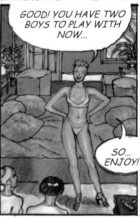

GOOD! YOU HAVE TWO BOYS TO PLAY WITH NOW...

SO... ENJOY!

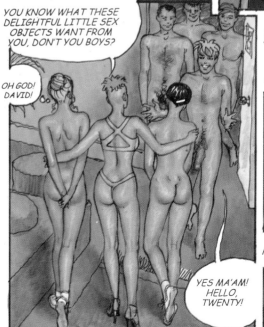

YOU KNOW WHAT THESE DELIGHTFUL LITTLE SEX OBJECTS WANT FROM YOU, DON'T YOU BOYS?

OH GOD! DAVID!

YES MA'AM! HELLO, TWENTY!

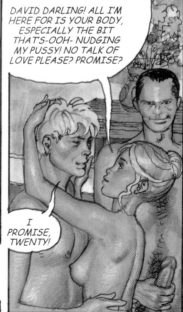

DAVID DARLING! ALL I'M HERE FOR IS YOUR BODY, ESPECIALLY THE BIT THAT'S-OOH- NUDGING MY PUSSY! NO TALK OF LOVE PLEASE? PROMISE?

I PROMISE, TWENTY!

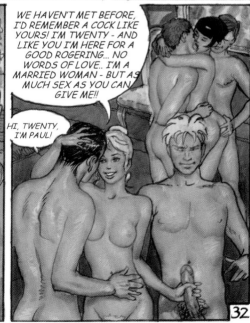

WE HAVEN'T MET BEFORE, I'D REMEMBER A COCK LIKE YOURS! I'M TWENTY - AND LIKE YOU I'M HERE FOR A GOOD ROGERING... NO WORDS OF LOVE.. I'M A MARRIED WOMAN - BUT AS MUCH SEX AS YOU CAN GIVE ME!!

HI, TWENTY, I'M PAUL!

32

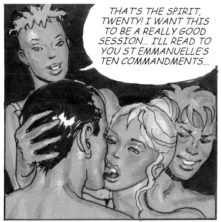

THAT'S THE SPIRIT, TWENTY! I WANT THIS TO BE A REALLY GOOD SESSION... I'LL READ TO YOU ST EMMANUELLE'S TEN COMMANDMENTS...

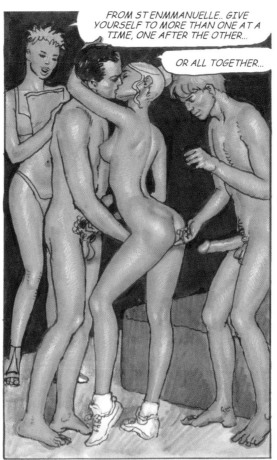

FROM ST EMMANUELLE.. GIVE YOURSELF TO MORE THAN ONE AT A TIME, ONE AFTER THE OTHER...

OR ALL TOGETHER...

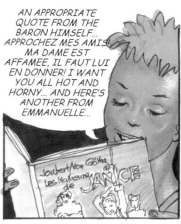

AN APPROPRIATE QUOTE FROM THE BARON HIMSELF... APPROCHEZ MES AMIS! MA DAME EST AFFAMEE, IL FAUT LUI EN DONNER! I WANT YOU ALL HOT AND HORNY... AND HERE'S ANOTHER FROM EMMANUELLE...

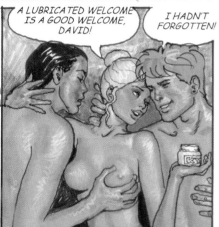

A LUBRICATED WELCOME IS A GOOD WELCOME, DAVID!

I HADN'T FORGOTTEN!

DELIGHT YOUR PALATE WITH LONG SPURTS OF SPERM...

DO YOU HEAR THAT BOYS?

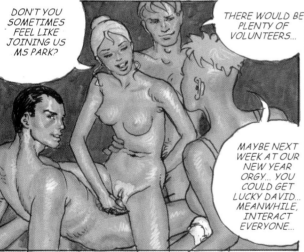

DON'T YOU SOMETIMES FEEL LIKE JOINING US MS PARK?

THERE WOULD BE PLENTY OF VOLUNTEERS...

MAYBE NEXT WEEK AT OUR NEW YEAR ORGY... YOU COULD GET LUCKY DAVID... MEANWHILE, INTERACT EVERYONE...

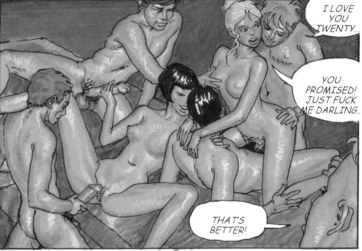

I LOVE YOU TWENTY...

YOU PROMISED! JUST FUCK ME DARLING..

THAT'S BETTER!

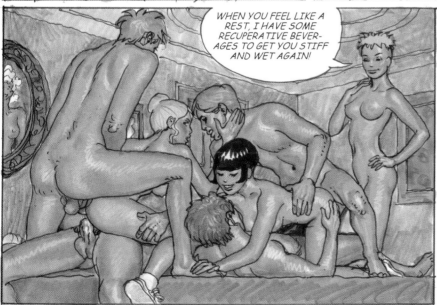

WHEN YOU FEEL LIKE A REST, I HAVE SOME RECUPERATIVE BEVERAGES TO GET YOU STIFF AND WET AGAIN!

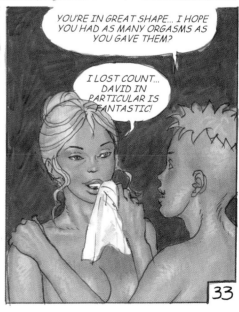

YOU'RE IN GREAT SHAPE... I HOPE YOU HAD AS MANY ORGASMS AS YOU GAVE THEM?

I LOST COUNT... DAVID IN PARTICULAR IS FANTASTIC!

33

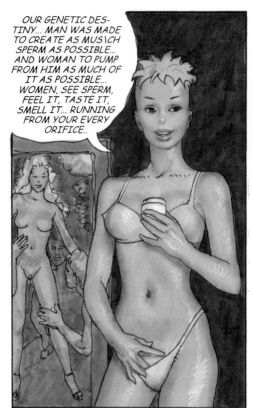

OUR GENETIC DESTINY... MAN WAS MADE TO CREATE AS MUS\CH SPERM AS POSSIBLE... AND WOMAN TO PUMP FROM HIM AS MUCH OF IT AS POSSIBLE... WOMEN, SEE SPERM, FEEL IT, TASTE IT, SMELL IT... RUNNING FROM YOUR EVERY ORIFICE..

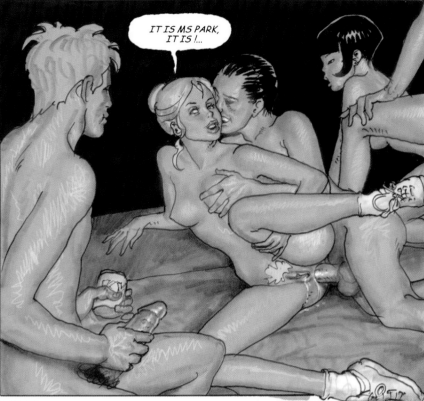

IT IS MS PARK, IT IS !...

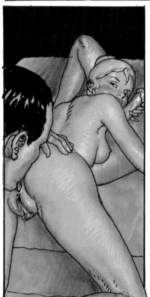

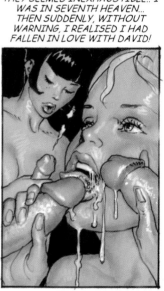

THEY SEEMED INEXHAUSTIBLE.. I WAS IN SEVENTH HEAVEN... THEN SUDDENLY, WITHOUT WARNING, I REALISED I HAD FALLEN IN LOVE WITH DAVID!

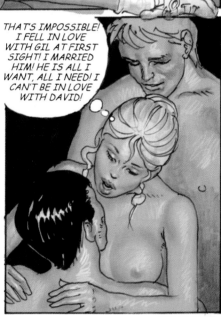

THAT'S IMPOSSIBLE! I FELL IN LOVE WITH GIL AT FIRST SIGHT! I MARRIED HIM! HE IS ALL I WANT, ALL I NEED! I CAN'T BE IN LOVE WITH DAVID!

I KNOW DAVID IS IN LOVE WITH ME, MS. PARK... AND NOW I'VE FALLEN IN LOVE WITH HIM!! IT'S IMPOSSIBLE! I'M A MARRIED WOMAN, I'M HAPPY!!

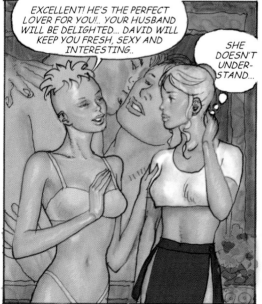

EXCELLENT! HE'S THE PERFECT LOVER FOR YOU!.. YOUR HUSBAND WILL BE DELIGHTED... DAVID WILL KEEP YOU FRESH, SEXY AND INTERESTING..

SHE DOESN'T UNDER-STAND...

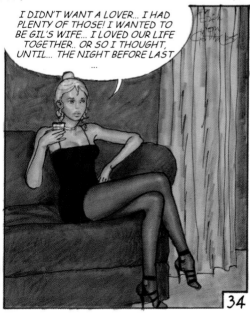

I DIDN'T WANT A LOVER... I HAD PLENTY OF THOSE! I WANTED TO BE GIL'S WIFE... I LOVED OUR LIFE TOGETHER.. OR SO I THOUGHT, UNTIL... THE NIGHT BEFORE LAST, ...

34

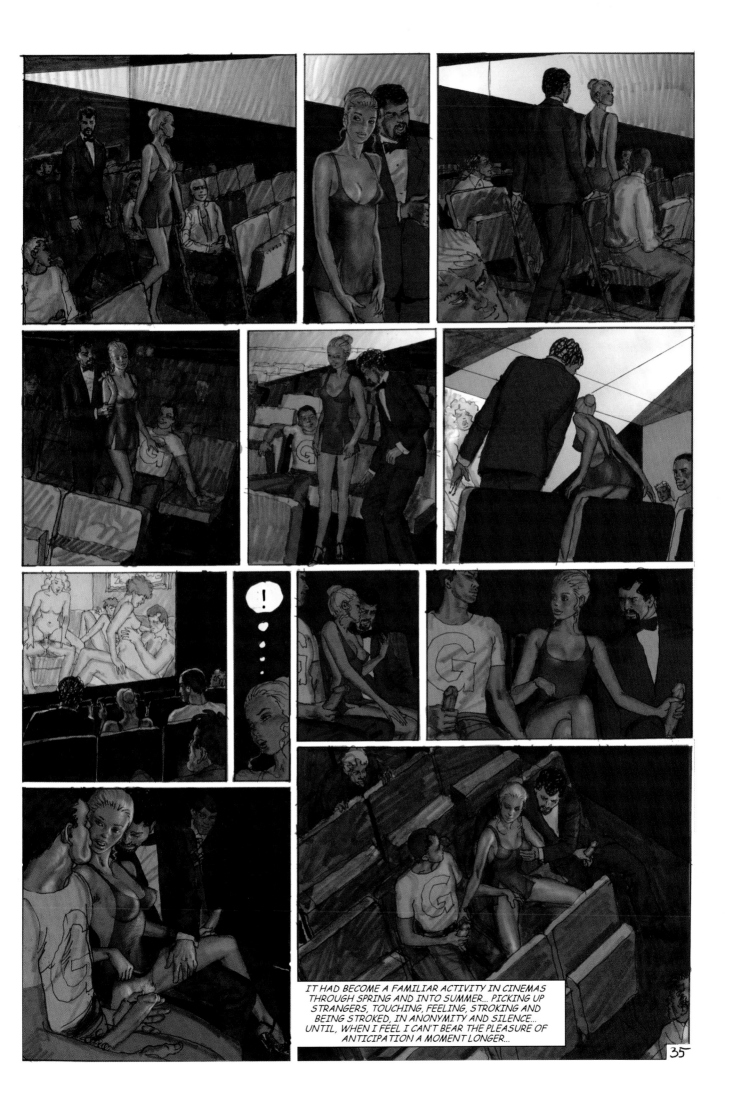

IT HAD BECOME A FAMILIAR ACTIVITY IN CINEMAS
THROUGH SPRING AND INTO SUMMER... PICKING UP
STRANGERS, TOUCHING, FEELING, STROKING AND
BEING STROKED, IN ANONYMITY AND SILENCE...
UNTIL, WHEN I FEEL I CAN'T BEAR THE PLEASURE OF
ANTICIPATION A MOMENT LONGER...

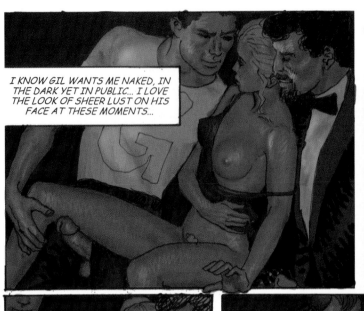

I KNOW GIL WANTS ME NAKED, IN THE DARK YET IN PUBLIC... I LOVE THE LOOK OF SHEER LUST ON HIS FACE AT THESE MOMENTS...

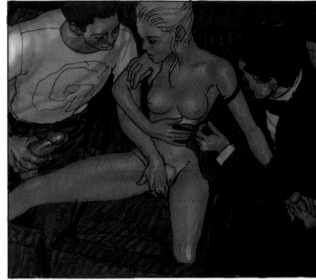

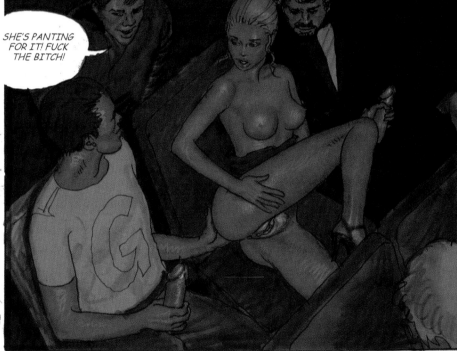

SHE'S PANTING FOR IT! FUCK THE BITCH!

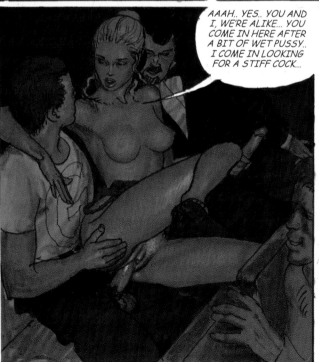

AAAH.. YES.. YOU AND I, WE'RE ALIKE... YOU COME IN HERE AFTER A BIT OF WET PUSSY.. I COME IN LOOKING FOR A STIFF COCK...

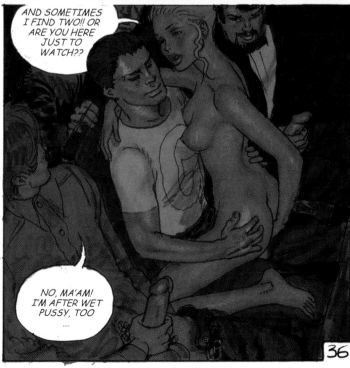

AND SOMETIMES I FIND TWO!! OR ARE YOU HERE JUST TO WATCH??

NO, MA'AM! I'M AFTER WET PUSSY, TOO ...

36

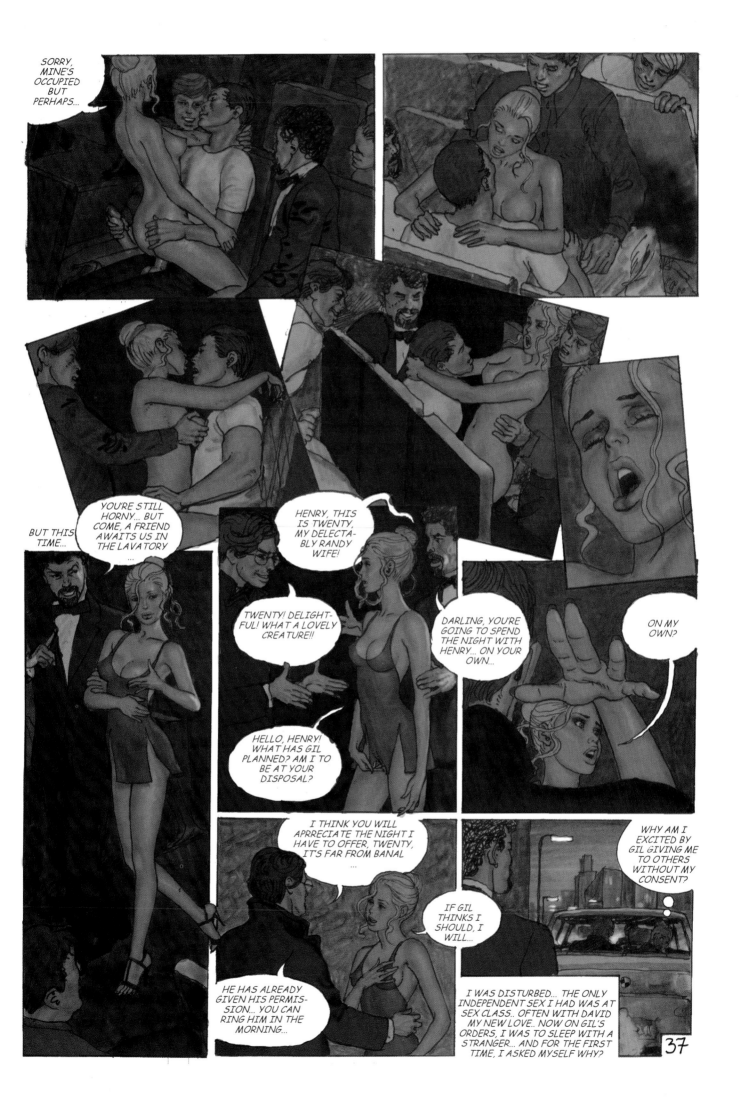

FIRST I WANT YOU TO MEET MY WIFE RACHEL... SHE'S EXPECTING US...

I WAS STUNNED! SUDDENLY ALL MY OLD DREAMS CAME FLOODING BACK... ONCE AGAIN I SAW MYSELF LIKE HER, NAKED, WHIPPED, SUBMISSIVE, IN CHAINS, AT THE MERCY OF ANYONE...

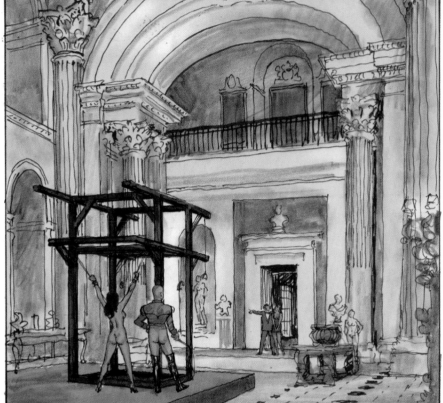

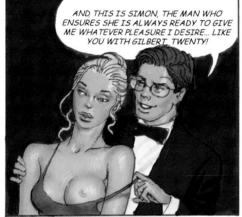

AND, THIS IS SIMON, THE MAN WHO ENSURES SHE IS ALWAYS READY TO GIVE ME WHATEVER PLEASURE I DESIRE... LIKE YOU WITH GILBERT, TWENTY!

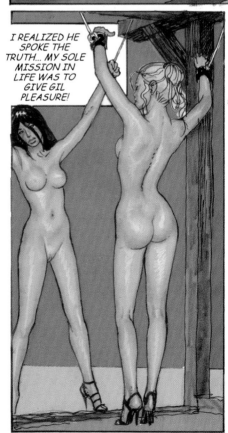

I REALIZED HE SPOKE THE TRUTH... MY SOLE MISSION IN LIFE WAS TO GIVE GIL PLEASURE!

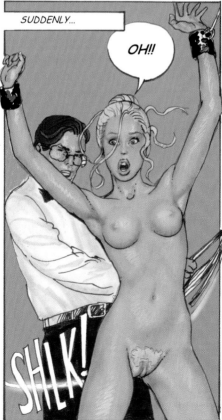

SUDDENLY...

OH!!

SHLK!

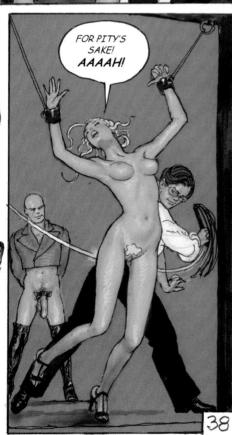

FOR PITY'S SAKE! AAAAH!

38

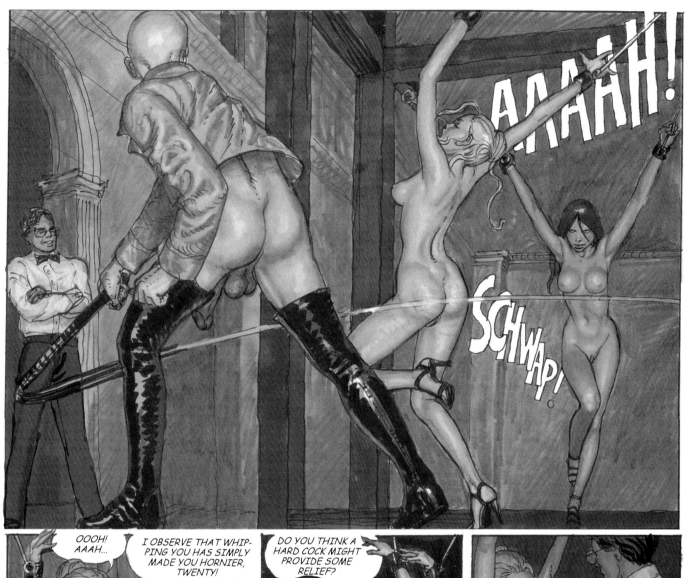

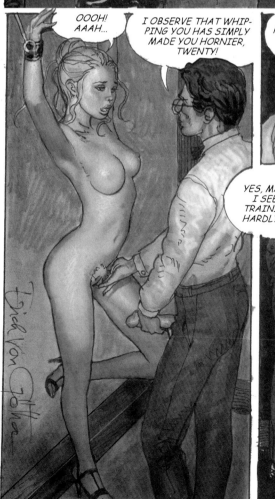

OOOH! AAAH...

I OBSERVE THAT WHIPPING YOU HAS SIMPLY MADE YOU HORNIER, TWENTY!

YES, MASTER!! .. I SEE YOUR TRAINING HAS HARDLY BEGUN!

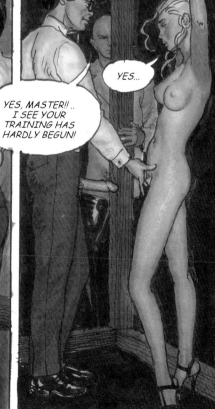

DO YOU THINK A HARD COCK MIGHT PROVIDE SOME RELIEF?

YES...

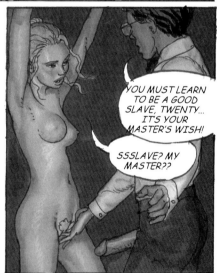

YOU MUST LEARN TO BE A GOOD SLAVE, TWENTY... IT'S YOUR MASTER'S WISH!

SSSLAVE? MY MASTER??

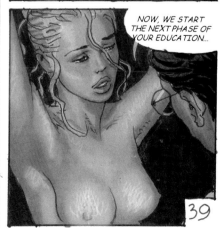

NOW, WE START THE NEXT PHASE OF YOUR EDUCATION...

39

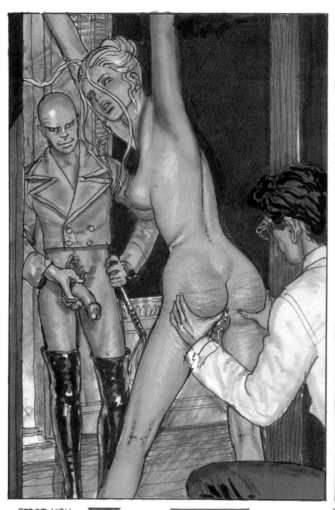

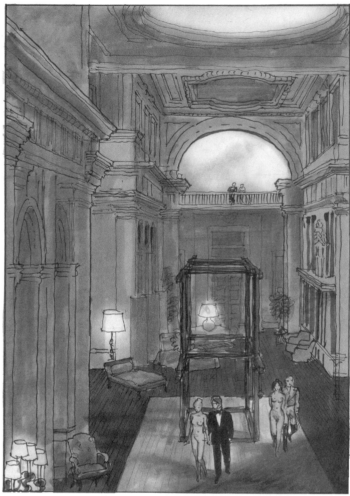

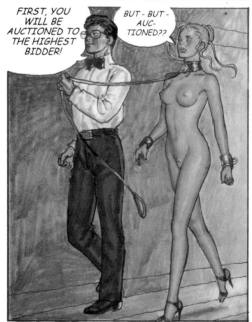

FIRST, YOU WILL BE AUCTIONED TO THE HIGHEST BIDDER!

BUT - BUT - AUC-TIONED??

OH!

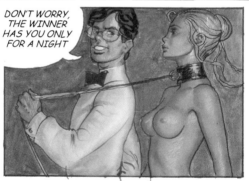

DON'T WORRY, THE WINNER HAS YOU ONLY FOR A NIGHT

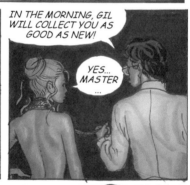

IN THE MORNING, GIL WILL COLLECT YOU AS GOOD AS NEW!

YES... MASTER ...

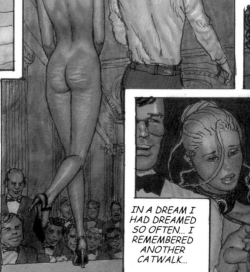

OH!! YOU'LL LOVE IT!

IN A DREAM I HAD DREAMED SO OFTEN... I REMEMBERED ANOTHER CATWALK...

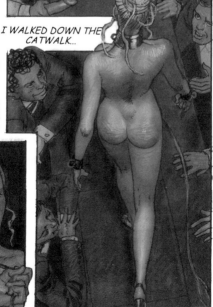

I WALKED DOWN THE CATWALK...

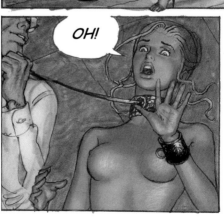

40

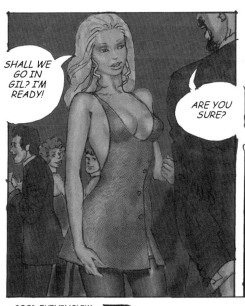

SHALL WE GO IN GIL? I'M READY!

ARE YOU SURE?

TWENTY... I HOPE YOU UNDERSTAND WHAT STRIPPING FOR THE WANKERS' CLUB WILL MEAN?

... AND WHAT ARE YOU WEARING UNDER YOUR DRESS?

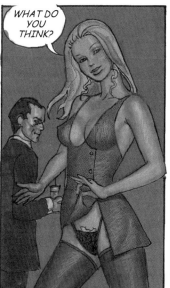

WHAT DO YOU THINK?

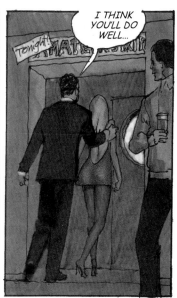

I THINK YOU'LL DO WELL...

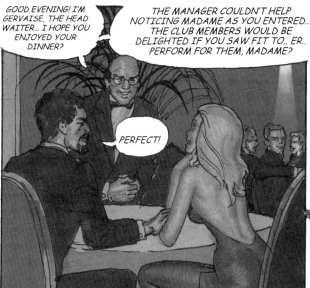

GOOD EVENING! I'M GERVAISE, THE HEAD WAITER... I HOPE YOU ENJOYED YOUR DINNER?

THE MANAGER COULDN'T HELP NOTICING MADAME AS YOU ENTERED... THE CLUB MEMBERS WOULD BE DELIGHTED IF YOU SAW FIT TO.. ER.. PERFORM FOR THEM, MADAME?

PERFECT!

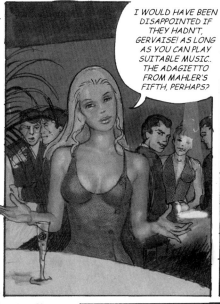

I WOULD HAVE BEEN DISAPPOINTED IF THEY HADN'T, GERVAISE! AS LONG AS YOU CAN PLAY SUITABLE MUSIC.. THE ADAGIETTO FROM MAHLER'S FIFTH, PERHAPS?

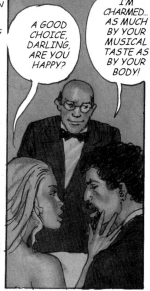

A GOOD CHOICE, DARLING, ARE YOU HAPPY?

I'M CHARMED... AS MUCH BY YOUR MUSICAL TASTE AS BY YOUR BODY!

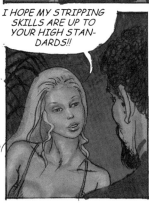

I HOPE MY STRIPPING SKILLS ARE UP TO YOUR HIGH STAN- DARDS!!

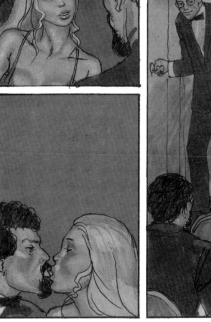

PERHAPS MADAME WOULD CARE TO FOLLOW ME...

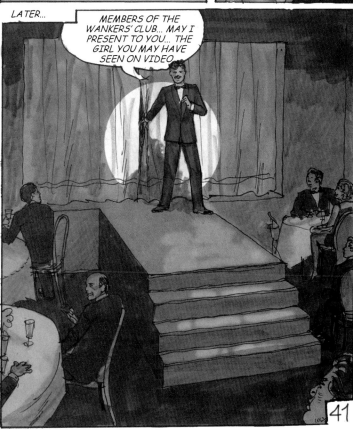

LATER...

MEMBERS OF THE WANKERS' CLUB... MAY I PRESENT TO YOU... THE GIRL YOU MAY HAVE SEEN ON VIDEO...

41

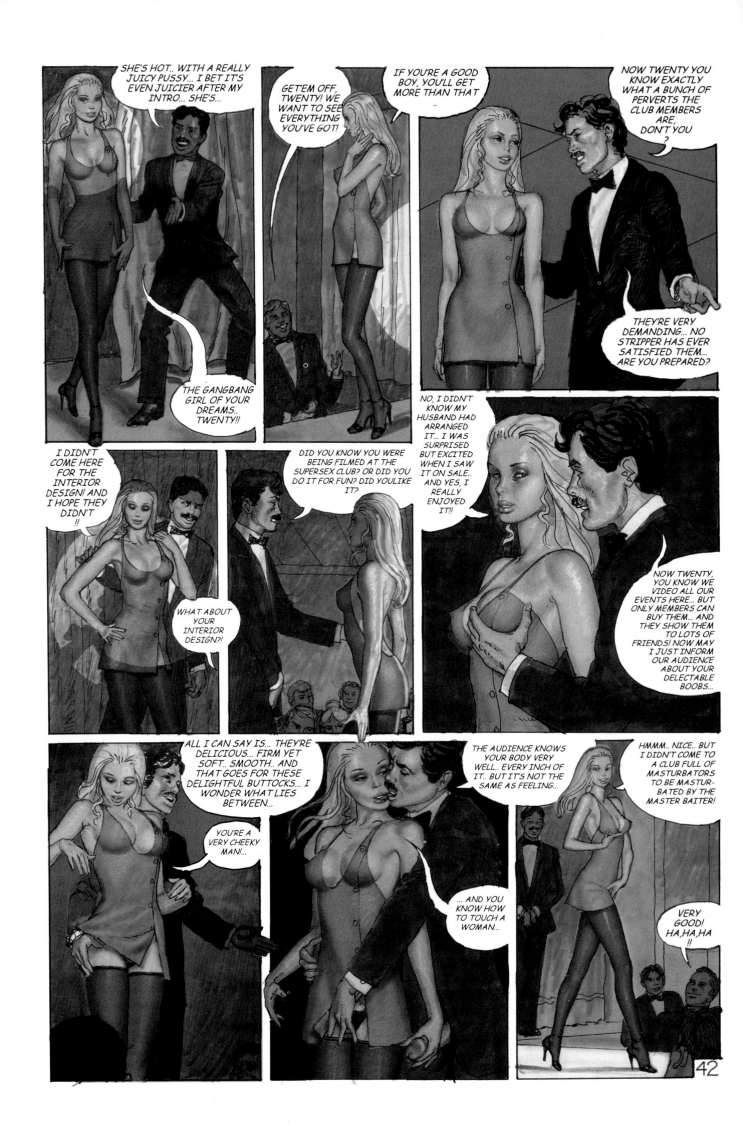

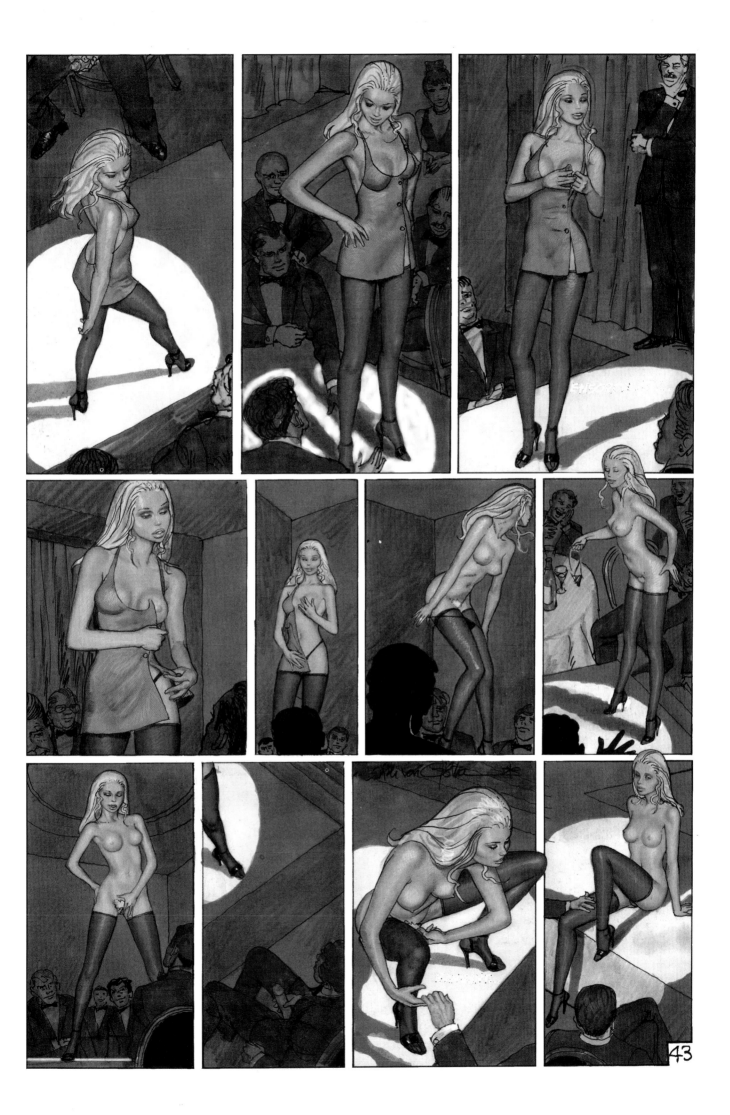

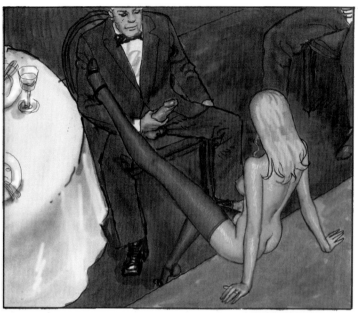

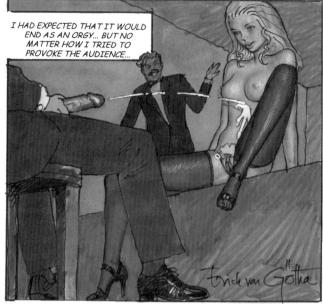

I HAD EXPECTED THAT IT WOULD END AS AN ORGY... BUT NO MATTER HOW I TRIED TO PROVOKE THE AUDIENCE...

ALL THEY WANTED WAS TO MASTURBATE OVER ME... OF COURSE.. THEY WERE THE WANKERS CLUB!!

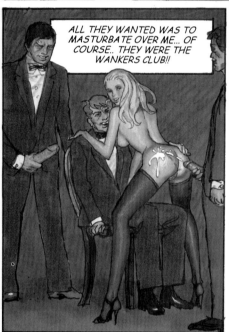

... I REMEMBERED ST EMMANUELLE AND REGRETTED THE FACT THAT I WAS CLEARLY NOT GOING TO BE ABLE TO OBEY HER 6TH COMMANDMENT: DELIGHT YOUR TENDER PALATE...

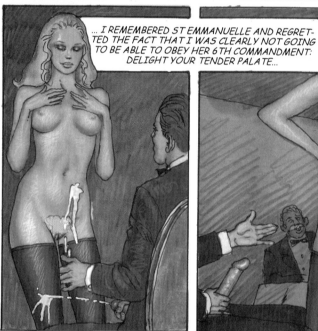

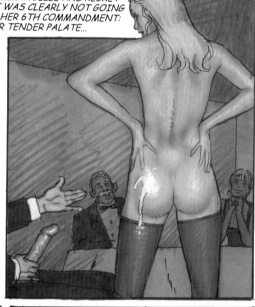

SPERM THERE WAS A-PLENTY, BUT THEY SEEMED CONTENT TO SPURT IT ANYWHERE BUT WHERE IT..

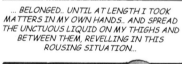

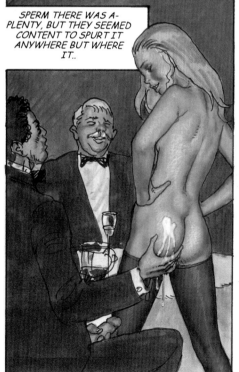

... BELONGED.. UNTIL AT LENGTH I TOOK MATTERS IN MY OWN HANDS.. AND SPREAD THE UNCTUOUS LIQUID ON MY THIGHS AND BETWEEN THEM, REVELLING IN THIS ROUSING SITUATION...

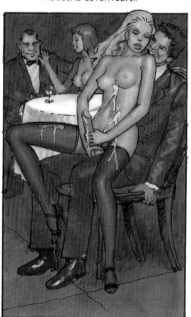

...UNTIL MY THOUGHTS RETURNED... HENRY HAD NOW STRUNG ME, HELPLESS, FROM THE LOFTY CEILING...

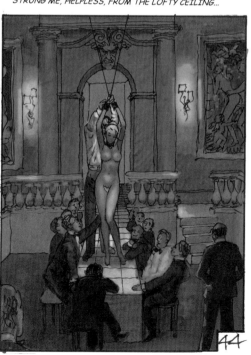

44

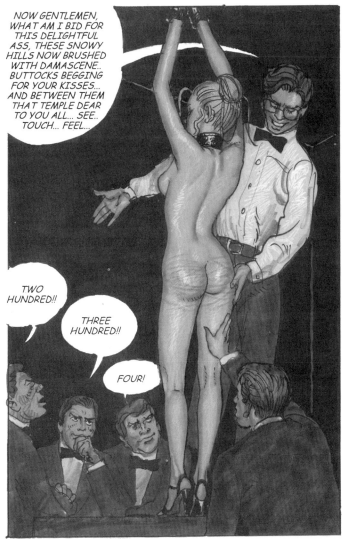

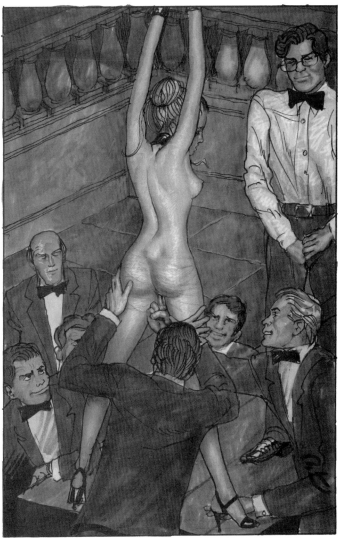

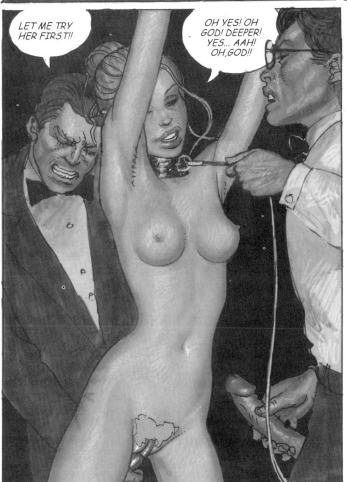

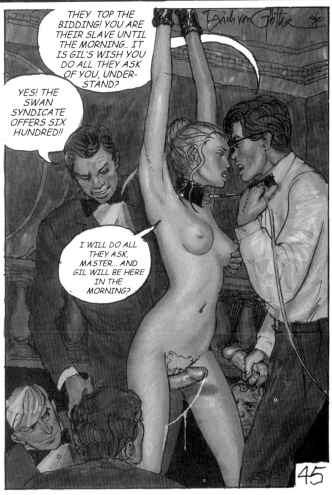

45

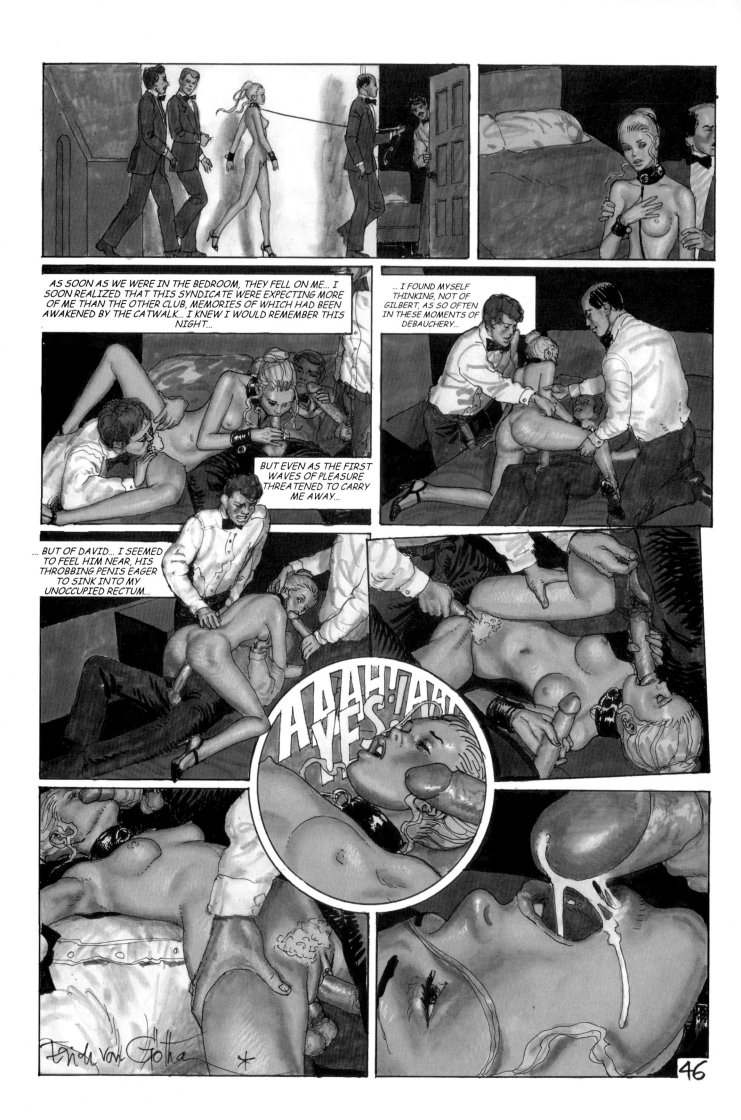

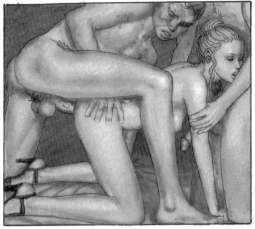

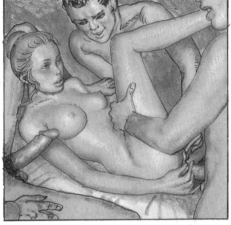

MORNING CAME.. AT LAST... A GLEAM OF
LIGHT THAT SEEMED SYMBOLIC...

AS I MOVED THE MOISTURES OF THE
NIGHT MOVED INSIDE OF ME...

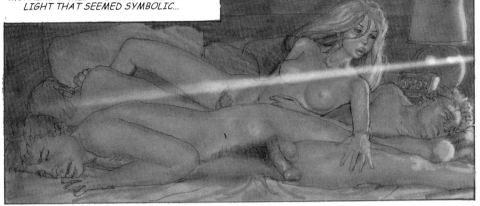

GIL, CAN YOU
FETCH ME? YES,
NOW... OH,...

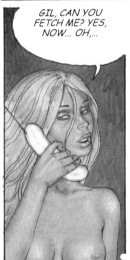

SHALL WE SAY
HALF AN HOUR?

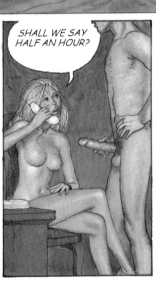

ER...

MAKE THAT AN
HOUR...

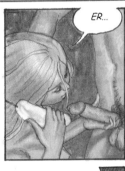

LATER...

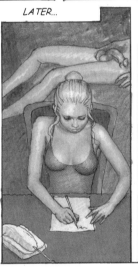

AND WHAT REPORT
WILL YOU GIVE
GILBERT?

FAR FROM
BANAL!

BUT I THOUGHT I
WAS TO PICK YOU
UP, MS ABBOTT...

I'M NOT COMING BACK,
AMOS.... JUST GIVE THIS
NOTE TO MY HUSBAND...
NOW I'M GOING BACK TO
THE SCHOOL...

I HAD SUDDENLY REALIZED GIL
HAD STOPPED MAKING LOVE TO
ME... INSTEAD HE ARRANGED FOR
OTHERS TO DO IT! WHY? WHY? I
WAS AMAZED AT MY NAIVETE...

I REALIZED MY MARRIAGE WAS
BASED ON A SCHOOLGIRL CRUSH...
AND NO DOUBT SO WAS MY
TRANSFER OF AFFECTION TO
DAVID... I MUST NOT MAKE THE
SAME MISTAKE TWICE... WAS MY
SEXUALITY MINE? OR GIL'S? I
DECIDED TO FIND OUT...

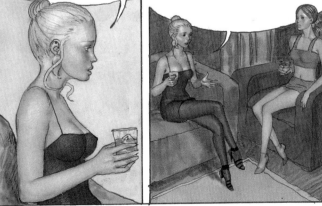

I HAD LUNCH .. AT SYBIL'S..

EXCUSE
ME...

IT WAS A BROCHURE...
SEEKING VOLUNTEERS FOR..
THE BOX... DOUBTLESS, YOU
KNOW IT?

OF COURSE
!!

47

THE GIRL, SALLY, EXPLAINED THE BOX TO ME IN DETAIL...

NOT EVERY WOMAN LIKES IT! ONE MUST BE CONTENT TO SIMPLY BE A SEX OBJECT!

LET ME BE FRANK.. IT'S ANONYMOUS SEX... YOU WON'T KNOW YOUR PARTNERS.. OR EVEN SEE THEM.. YOU'LL BE A MERE RECEPTACLE FOR SEMEN, IN EVERY ORIFICE. THEY WILL BE ABLE TO SEE YOU, BUT YOU WILL BE MASKED SO THEY DON'T KNOW WHO YOU ARE.. YOU WILL BE TEAMED WITH A CHARMING WOMAN WHO LOVES IT.. I'LL INTRODUCE YOU...

PERHAPS AN OCCASIONAL VISIT.. BUT THE WOMEN HAVE NO CONTROL...

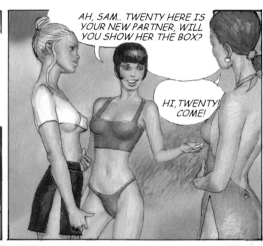

AH, SAM.. TWENTY HERE IS YOUR NEW PARTNER, WILL YOU SHOW HER THE BOX?

HI, TWENTY! COME!

MY HUSBAND AND I GO TO PARTIES... I LOVE THE PROMISCUITY.. HE LOVES TO FUCK ME WHEN WE GET HOME...

LUCKY SAM! I WISH GIL DID THAT...

WE BOTH LOVE IT WHEN I'M FULL OF OTHER MEN'S SEMEN!

THE BOX SEEMED IDEAL FOR US! I WENT AT ONCE...

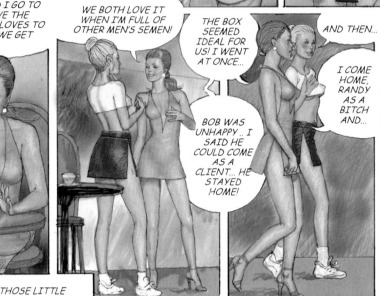

BOB WAS UNHAPPY.. I SAID HE COULD COME AS A CLIENT... HE STAYED HOME!

I COME HOME, RANDY AS A BITCH AND...

AND THEN...

.. BRIMMING WITH SPUNK! HERE IS THE TURNSTILE.. I HAVE TOKENS TO ENTER...

FORTUNATELY..

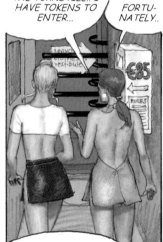

TEMPTING, I KNOW, TWENTY, BUT UT'S AGAINST THE RULES... WAIT TILL YOU ARE IN THE BOX!

JUST VISITING, BOYS..

THOSE LITTLE TV SCREENS...

COME AND HAVE A LOOK...

OR HAVE YOU COME TO WATCH US?

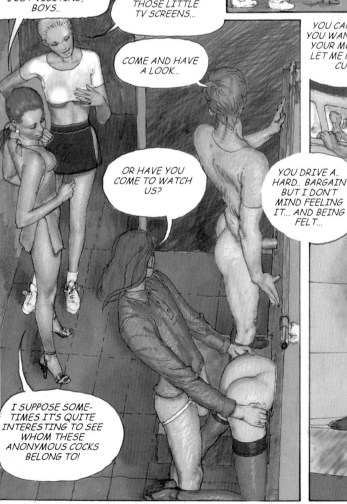

I SUPPOSE SOMETIMES IT'S QUITE INTERESTING TO SEE WHOM THESE ANONYMOUS COCKS BELONG TO!

YOU CAN LOOK IF YOU WANK ME INTO YOUR MOUTH AND LET ME FEEL YOUR CUNT...!

YOU DRIVE A.. HARD.. BARGAIN BUT I DON'T MIND FEELING IT... AND BEING FELT...

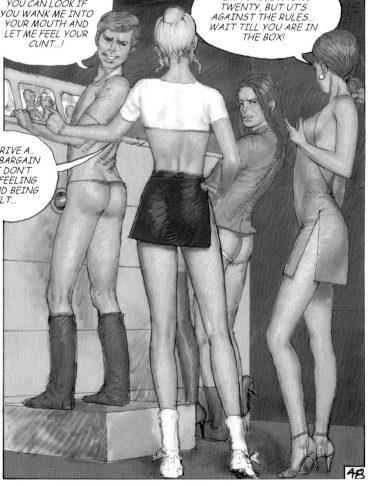

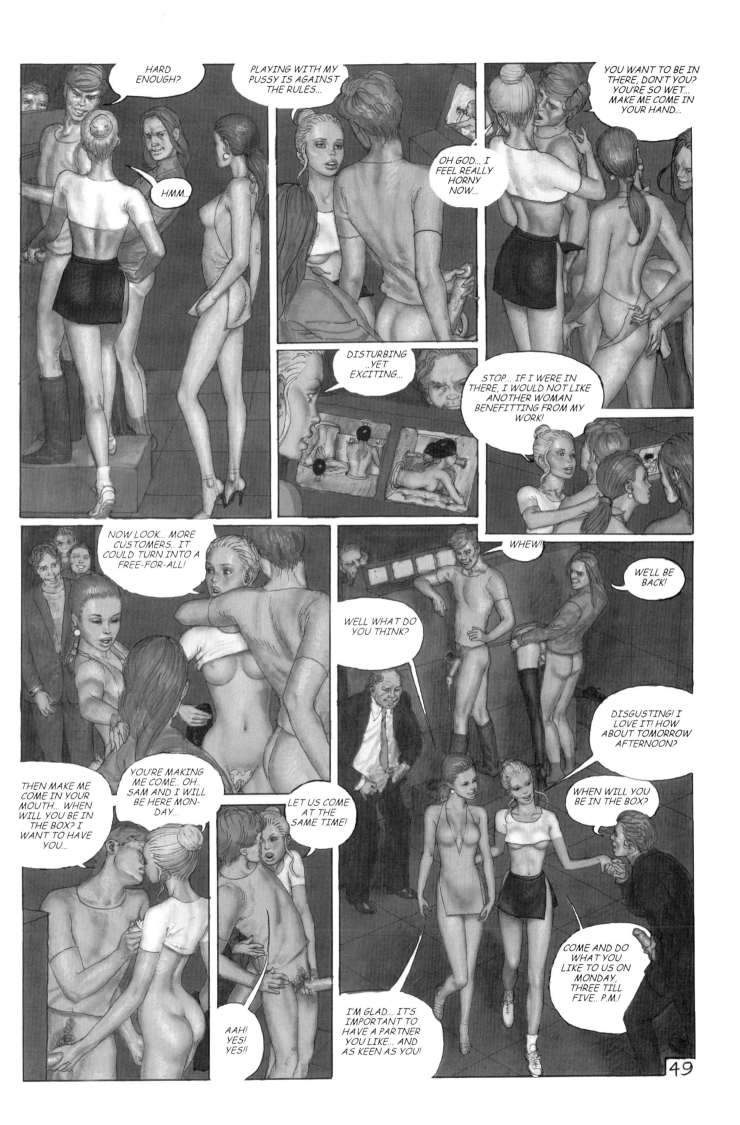

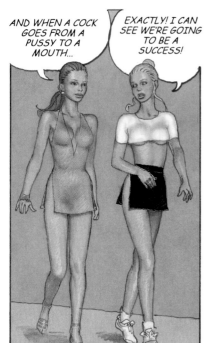

AND WHEN A COCK GOES FROM A PUSSY TO A MOUTH...

EXACTLY! I CAN SEE WE'RE GOING TO BE A SUCCESS!

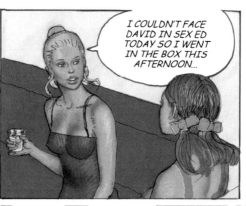

I COULDN'T FACE DAVID IN SEX ED TODAY SO I WENT IN THE BOX THIS AFTERNOON...

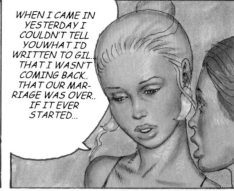

WHEN I CAME IN YESTERDAY I COULDN'T TELL YOU WHAT I'D WRITTEN TO GIL.. THAT I WASN'T COMING BACK.. THAT OUR MARRIAGE WAS OVER.. IF IT EVER STARTED...

AS FOR MY EXPERIMENT...

OH YES, TELL ME - OH THE DOORBELL!

Diling! Diling!

I'LL GO! WHO ON EARTH-? SOMEONE FOR YOU?

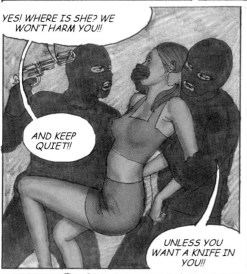

YES! WHERE IS SHE? WE WON'T HARM YOU!!

AND KEEP QUIET!!

UNLESS YOU WANT A KNIFE IN YOU!!

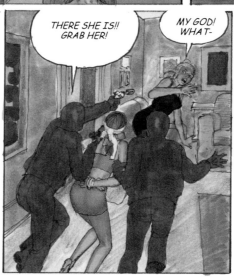

THERE SHE IS!! GRAB HER!

MY GOD! WHAT-

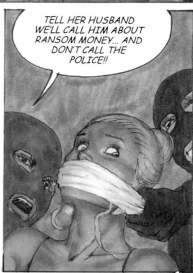

TELL HER HUSBAND WE'LL CALL HIM ABOUT RANSOM MONEY... AND DON'T CALL THE POLICE!!

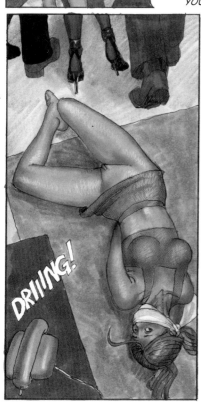

DRIING!

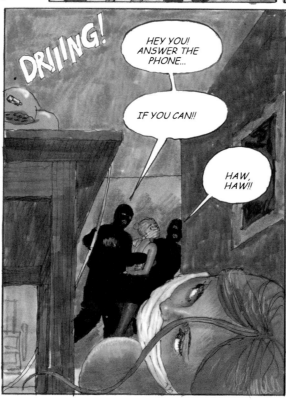

DRIING!

HEY YOU! ANSWER THE PHONE...

IF YOU CAN!!

HAW, HAW!!

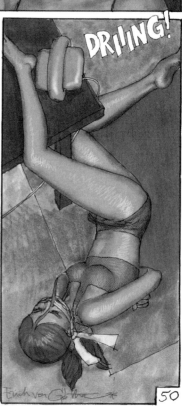

DRIING!

50

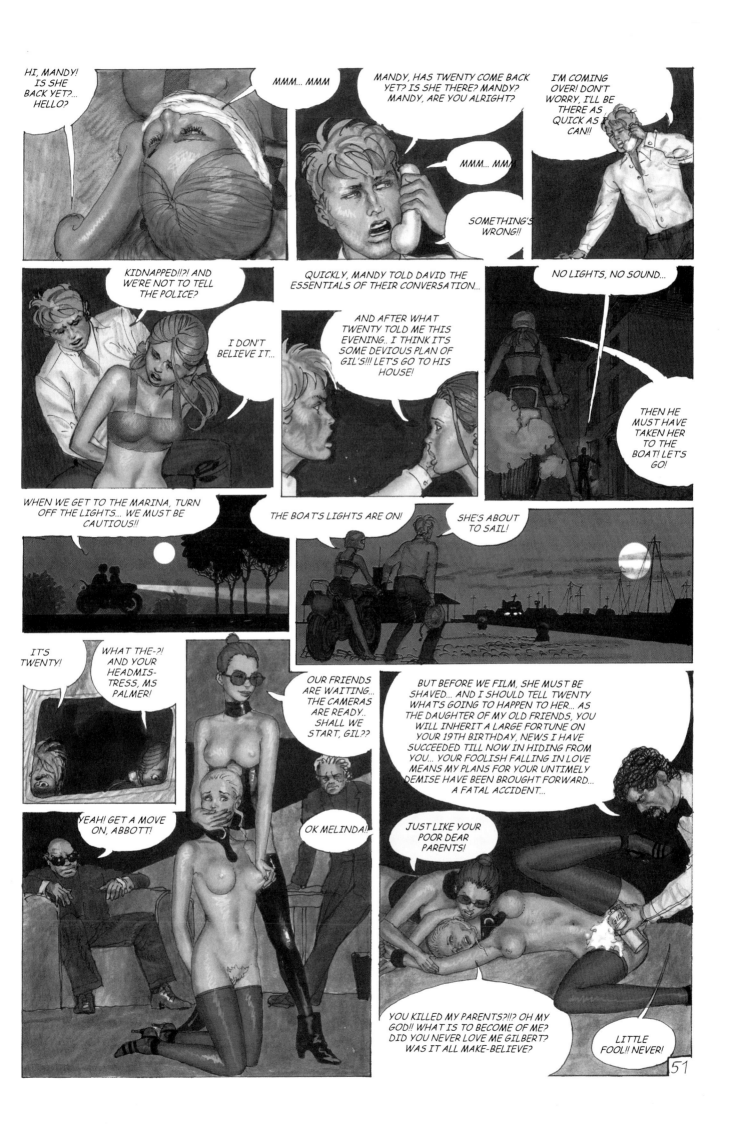

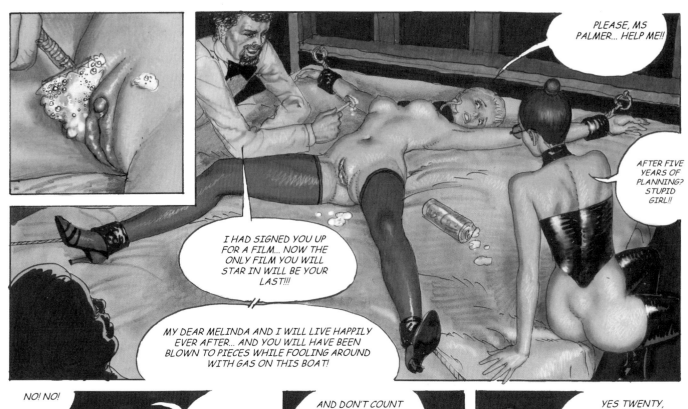

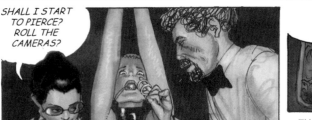

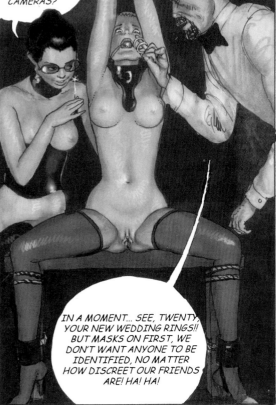

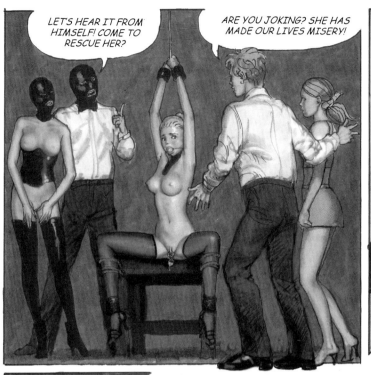

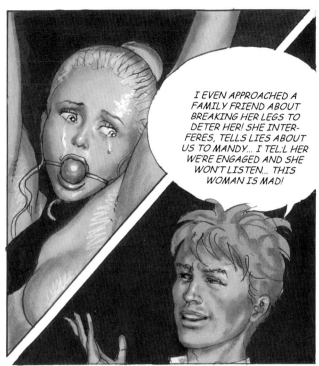

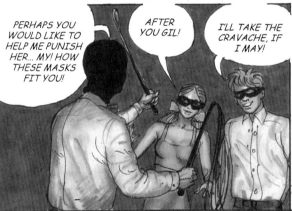

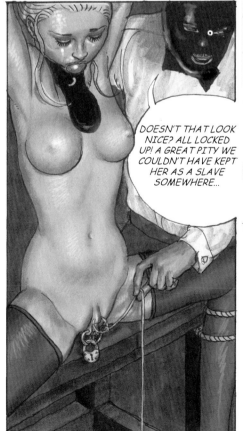

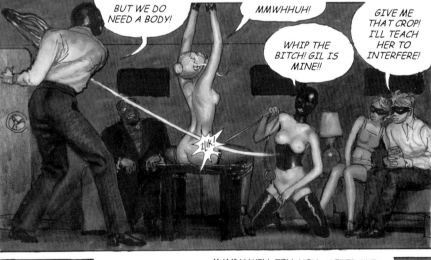

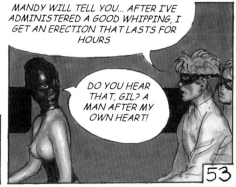

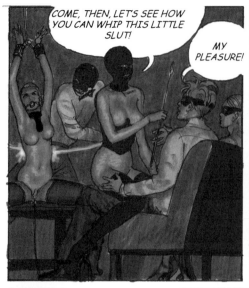

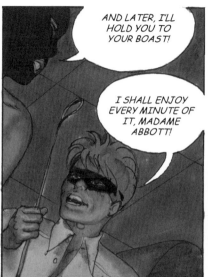

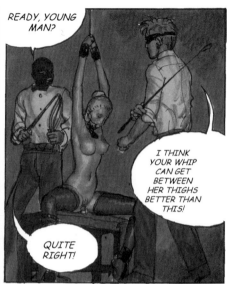

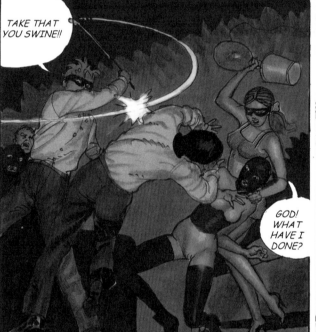

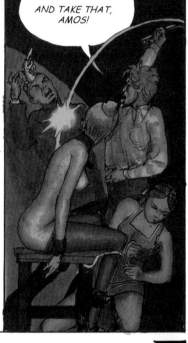

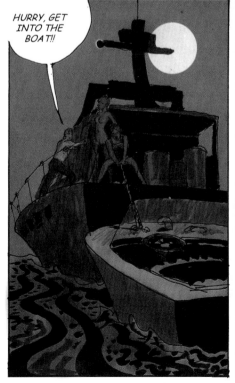

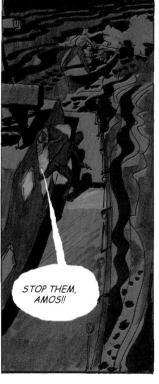

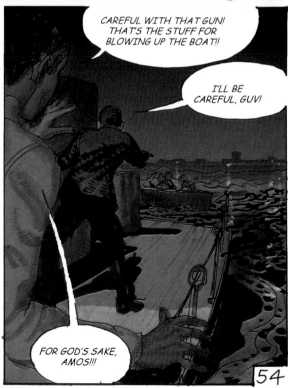

54

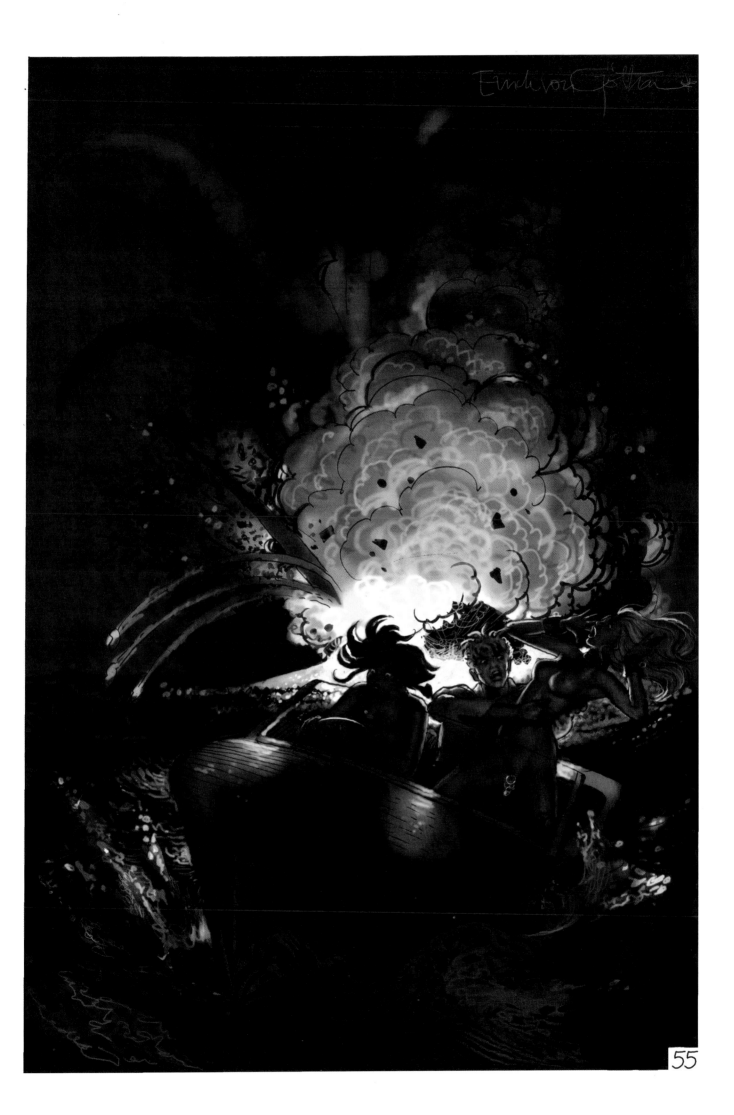

TIME PASSED IN A HAZE FOR TWENTY...

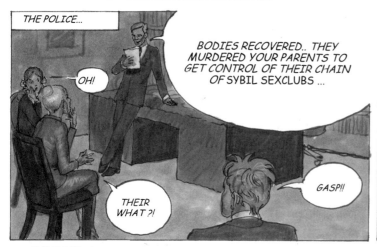

THE POLICE...

OH!

BODIES RECOVERED.. THEY MURDERED YOUR PARENTS TO GET CONTROL OF THEIR CHAIN OF SYBIL SEXCLUBS ...

THEIR WHAT ?!

GASP!!

THE LAWYER ...

MR ABBOTT'S LAWYER IS IN CUSTODY... CONSPIRACY TO STEAL PROPERTIES, TWO SCHOOLS, CLIFFORDS AND SANDERS .. EVEN YOU ARE UNDER SUSPICION .. YOUR GUARDIANS HAVE RUN AWAY .. THEY ARE ALSO SUSPECTS...

NO!

THE FUNERAL...

THE POLICE AGAIN ...

YOUR GUARDIANS HAVE BEEN CAUGHT .. WE HAVE A FULL CONFESSION ...

THE LAWYER ...

... YOU WILL INHERIT ...

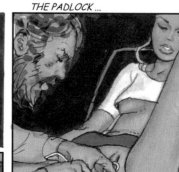

THE PADLOCK ...

THE RINGS ...

THESE NEW ONES ARE LIGHTER AND SEXIER !

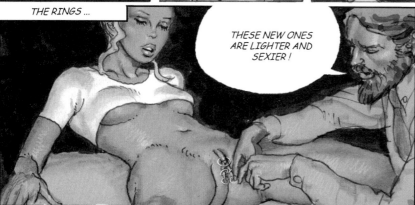

I'M ALONE IN THE WORLD ...

POOR TWENTY !

AND LONG DAYS OF BLACK DEPRESSION ...

UNTIL AT LAST ...

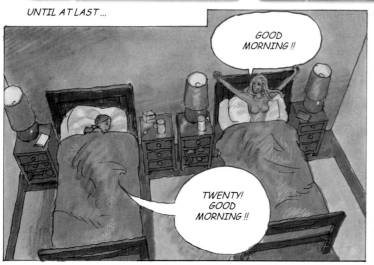

GOOD MORNING !!

TWENTY! GOOD MORNING !!

FEELING BETTER ?

YES .. LET'S GO SHOPPING!

56

SO, YOU HAVE LOST ALL INTEREST IN SEX?

NO! I DON'T WANT A MAN IN MY LIFE AGAIN, YET...

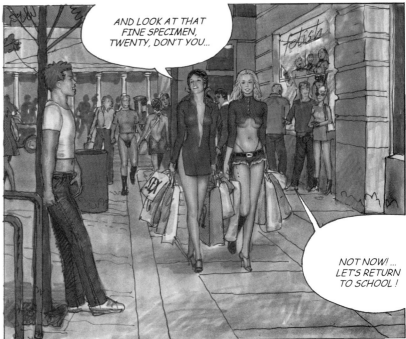

AND LOOK AT THAT FINE SPECIMEN, TWENTY, DON'T YOU...

NOT NOW! ... LET'S RETURN TO SCHOOL!

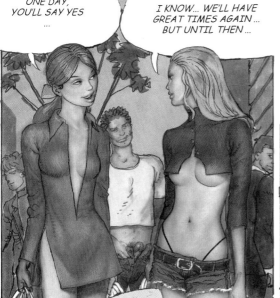

ONE DAY, YOU'LL SAY YES ...

I KNOW... WE'LL HAVE GREAT TIMES AGAIN ... BUT UNTIL THEN ...

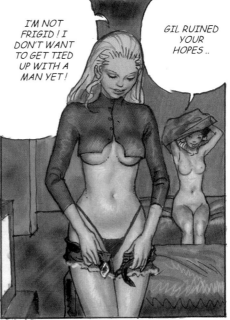

I'M NOT FRIGID! I DON'T WANT TO GET TIED UP WITH A MAN YET!

GIL RUINED YOUR HOPES ..

SO IF I SAY NO, EVEN TO DAVID, THE MAN I LOVE, IT'S NOT FOREVER .. I REMEMBER THE SEX CLASS, THE STRIP CLUB ... BE PATIENT WITH ME ...

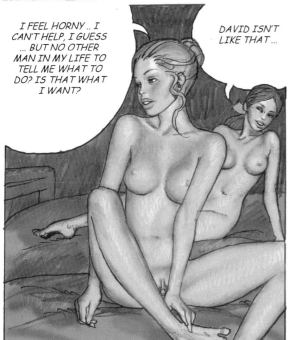

I FEEL HORNY .. I CAN'T HELP, I GUESS ... BUT NO OTHER MAN IN MY LIFE TO TELL ME WHAT TO DO? IS THAT WHAT I WANT?

DAVID ISN'T LIKE THAT ...

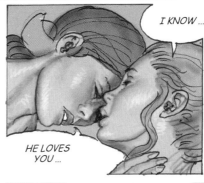

I KNOW ...

HE LOVES YOU ...

IT WOULD BE SO GOOD ..

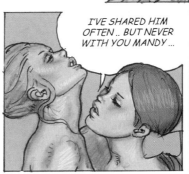

I'VE SHARED HIM OFTEN .. BUT NEVER WITH YOU MANDY ...

HMM. MAYBE I'LL CALL HIM...

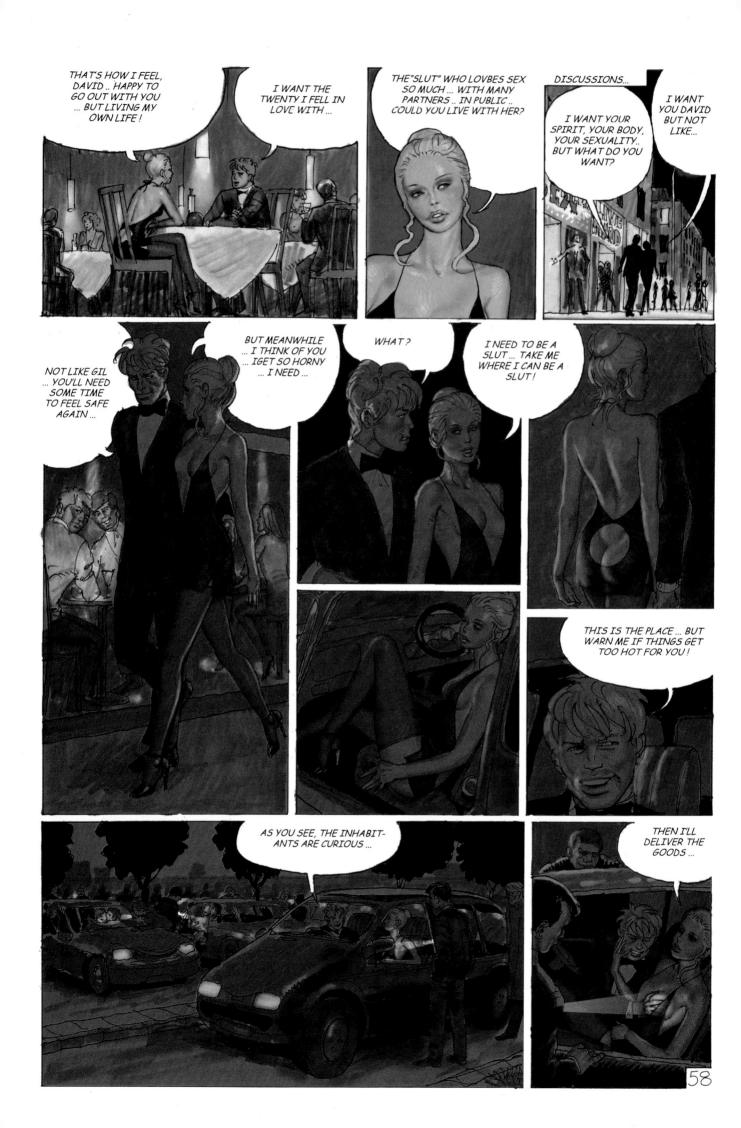

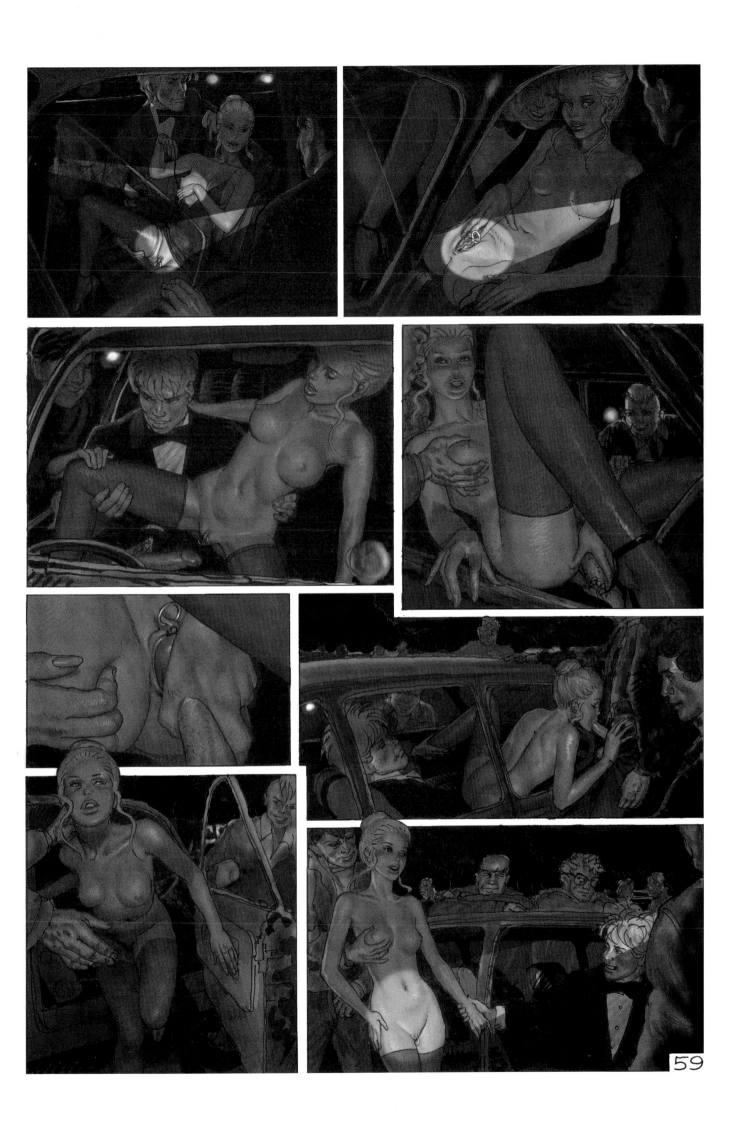

59

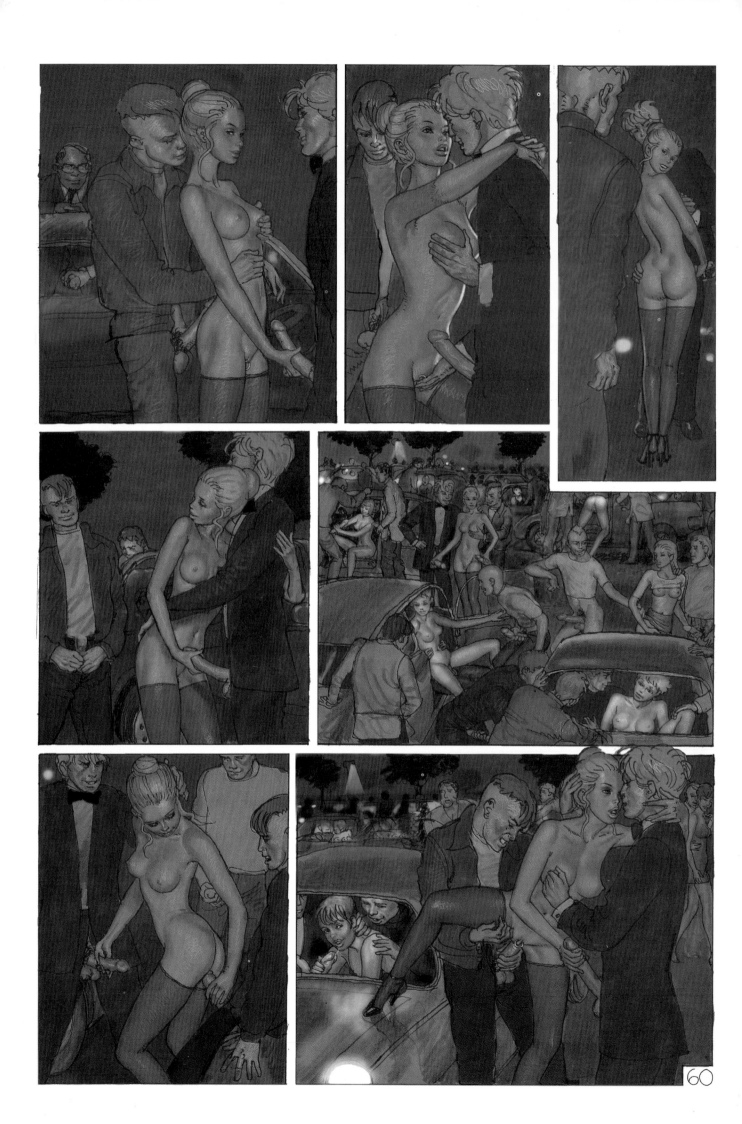

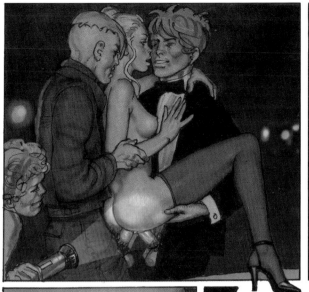

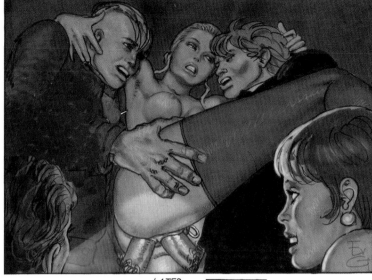

I LOVE YOU, DAVID!

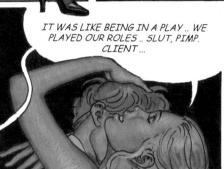

IT WAS LIKE BEING IN A PLAY .. WE PLAYED OUR ROLES .. SLUT, PIMP. CLIENT ...

WHICH REMINDS ME ... TELL ME ABOUT THAT END-OF-TERM SKIT YOU WANT ME TO ACT IN ... IS IT SEXY ? DO I TAKE MY CLOTHES OFF?

LATER...

AND NOW .. THE BRIDE SKIT ...!

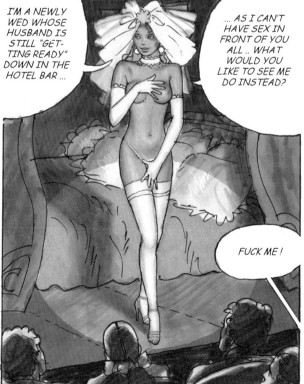

I'M A NEWLY WED WHOSE HUSBAND IS STILL "GETTING READY" DOWN IN THE HOTEL BAR ...

... AS I CAN'T HAVE SEX IN FRONT OF YOU ALL .. WHAT WOULD YOU LIKE TO SEE ME DO INSTEAD?

FUCK ME !

HMMM .. NICE IDEA... BUT WHAT IF MY HUSBAND ARRIVES ?

NO.. THERE MUST BE SOMETHING ELSE ...

PLAY WITH YOURSELF !!

EXCELLENT! JUST WHAT I WAS THINKING ABOUT !1

TOC! TOC!

BUT, HARK ! WHO'S THIS AT THE DOOR ?

61

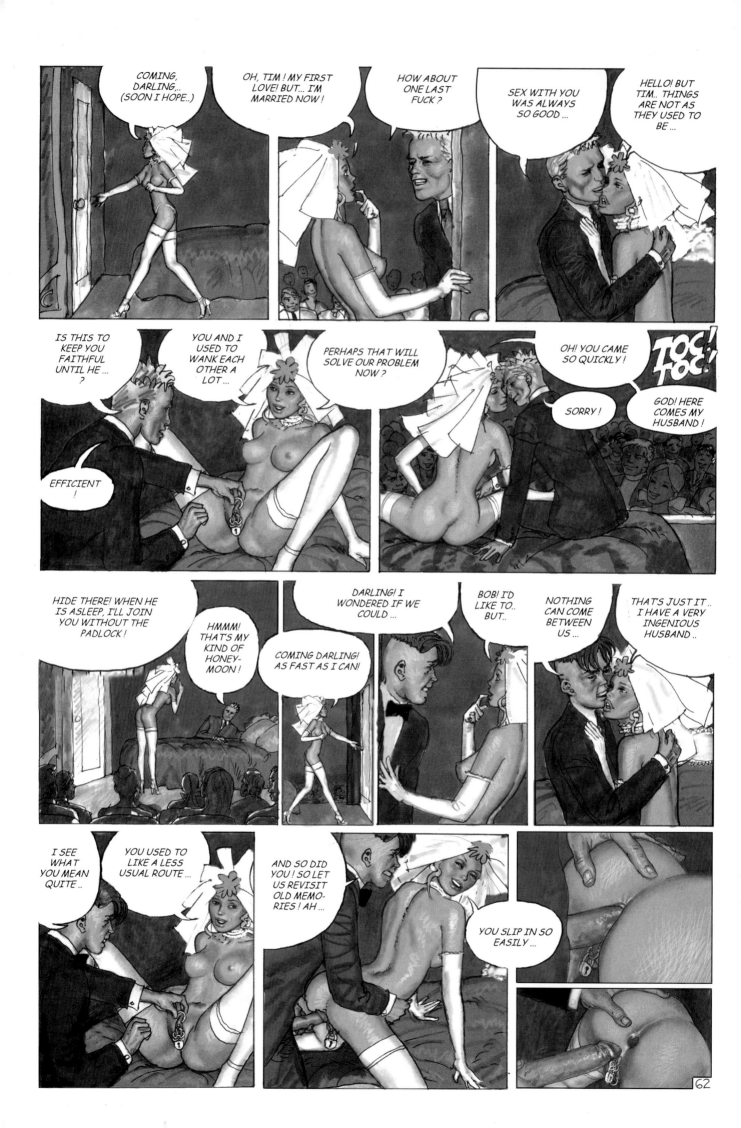

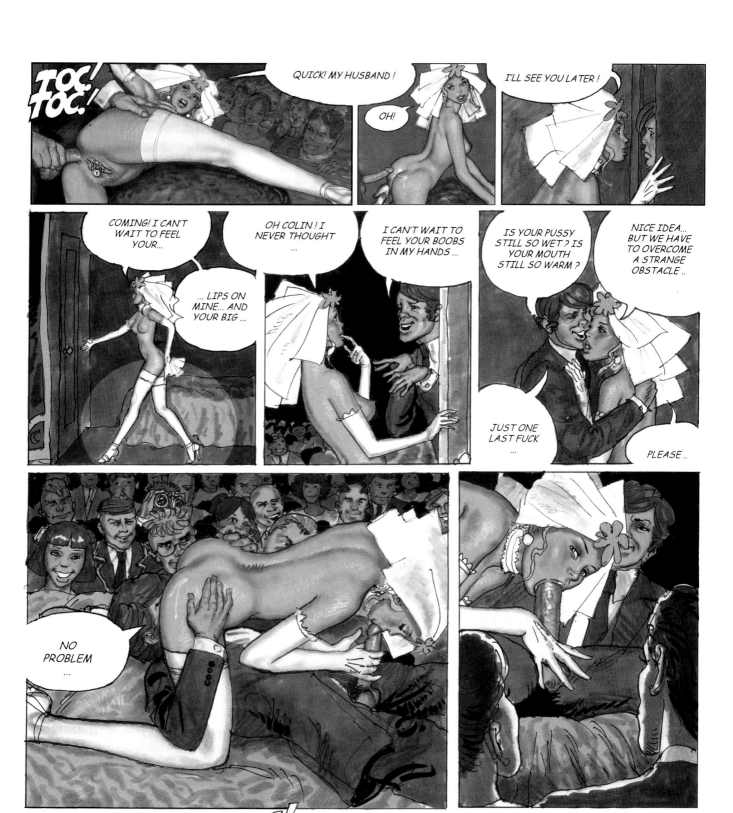
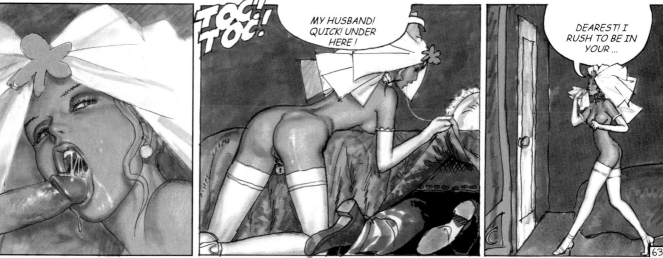

63

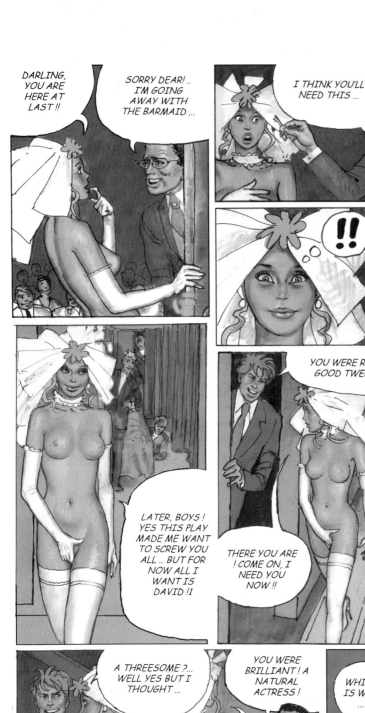

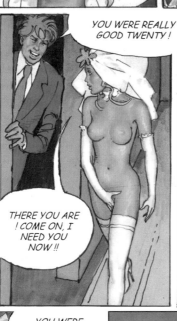

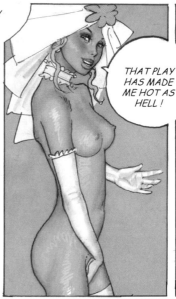

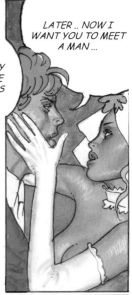

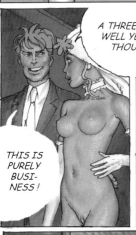

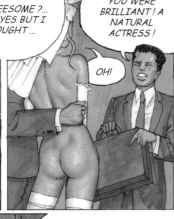

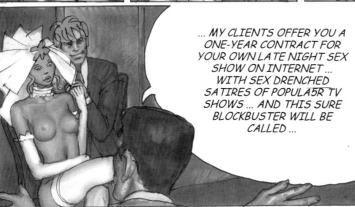

END